klee

Hans L. Jaffé

Hamlyn

London New York Sydney Toronto

twentieth-century masters
General editors: H. L. Jaffé and A. Busignani

© Copyright in the text by Sadea/Sansoni, Florence 1971
© Copyright in the illustrations by Cosmopress, Geneva 1971
© Copyright this translation The Hamlyn Publishing Group Limited 1972
London · New York · Sydney · Toronto
Hamlyn House, Feltham, Middlesex, England
ISBN 0 600 35304 4

Colour lithography by: Zincotipia Moderna, Florence
Printed in Italy by Industria Grafica L'Impronta, Scandicci, Florence
Bound in Italy by: Poligrafici il Resto del Carlino, Bologna
Photo-typeset by: Photoprint Plates, Rayleigh, Essex

Distributed in the United States of America by Crown Publishers Inc.

contents

List of colour plates

List of black-and-white illustrations

Klee's life

The events of Paul Klee's life are not particularly important compared with the history of his work, for nothing decisive or dramatic occurred in it except two events that affected nearly everyone in Europe during the first half of the century: the First World War and the rise of Nazism. Klee kept his life separate as far as possible from these two historical events; his work as an artist, and his life itself, were concerned above all with meditation and research, the results of which became increasingly clear as he developed.

What mattered in his life, then, was this inner development. Grohmann, who wrote the first detailed and authoritative biography of him, compared Klee's life with a plant growing from year to year, its growth quite unconcerned with particular dates and facts. However, an analysis of his inner development does need to be coupled with the external events that ran parallel to it. This is not so much because they influenced his activity, which seemed to take place quite outside time, but because of the influence his work and personality had on other artists, his contemporaries. For Klee's life, which was so retiring and withdrawn, became a model for the small world of art and artists, and after his death it was accepted as such by a much wider circle.

Paul Klee was born on December 18th, 1879, at Münchenbuchsee, near Berne. His father, who came from Thuringia, was a teacher of music in the cantonal teacher's training college at Berne-Hofwyl; his mother, who came from Basle, had also had a musical education. The fact that Klee grew up in the midst of music was important for his later development; his desire for harmony and his interest in the abstract structure of musical periods was one of the fundamentals of his work as a painter. Throughout his life he remained faithful to this love of music, which was so deeply rooted in his childhood; indeed, he was a good violinist and a constant opera- and concert-goer.

Perhaps the only special thing about his early years was this musical education of his, at any rate, the only thing that distinguished him from other boys. Like them, he went to primary school in Berne from 1866, on to high school in 1890, and in the winter of 1898 took his school-leaving exams on the classical side.

In the short autobiography which Klee wrote a few months before his death, in which he records the most important stages of his life, he says: 'From an exterior point of view, I had ample choice of profession. My school-leaving certificate meant that I could have taken up anything, but I wanted to be trained as a painter, and to make painting my life's work. At that time – and indeed, even today – this meant going abroad. The only choice I had to make lay between Paris and Germany. My own feelings in the matter took me to Germany.'

So he set off 'for the Bavarian metropolis', where at the start the Academy

sent him to a private art school. In 1898, then, Klee's artistic training and career began at Knirr's in Munich, first with a series of drawings, and in particular with studies from the nude. These sketches were certainly not his first efforts—we know of an album of drawings from his school days—but they are certainly the first works he considered important enough to be called artistic experiments. They are typical student works, and do not wholly reveal the future painter; they are the work of a young man 'being educated in painting', or, as he said much later, 'finding his way among forms'. At Knirr's he continued to learn and experiment, as he did later at the Academy with Franz von Stück, both theoretically, by taking courses in the history of art and in anatomy, and by reading a great deal, not only about art and painting but in all fields. On the technical side he started 'from details', for instance, he learnt the technique of etching. Perhaps his musical background made him realise that in order to produce a pure note, he must have perfect mastery of his instrument. By 1901 he felt his apprenticeship was over; he was grateful to his teachers, and said goodbye in this spirit to Franz von Stück. When his studies were over he felt he must make a trip to Italy to see the works of the Renaissance.

In the summer of 1901 he travelled with the sculptor Hermann Haller from Berne to Milan and Genoa, thence by sea to Leghorn and then on to Rome, where he spent the winter. He was in Naples at Easter in 1902, and visited Pompeii; in May he went back to Berne.

Until 1906 he worked in Berne, except for a few intervals. In 1902 he returned to Munich for a short visit and became engaged to the pianist Lily Stumpf; she was a doctor's daughter there, whom he had met because they both had musical interests.

In 1904 he visited Munich for a longer period, and made an intensive study of the Graphischen Kabinett. For the works of Beardsley, Blake and Goya he felt a profound admiration, appreciative not only of their technique but also of their style. Between 1903 and 1905 he made ten etchings, entitled 'Inventions', clearly inspired by the great graphic artists. In 1905 he paid a short visit to Paris with his friend Bloesch and the painter Moilliet, and once more he was stirred by the work of Leonardo da Vinci, who had made such a profound impression on him during his trip to Italy. He seems to have met no other contemporary artists—for instance, the Fauves, who were soon to become known. But in his work at the time certain parallels with other painters can be found, for instance, in his use of the technique of painting on glass, which recalls what Matisse and his friends were doing at the time. But Klee was really interested in continuing his own studies: in 1906 he visited Berlin, in particular to see the Kaiser Friedrich Museum, created by Wilhelm von Bode, and at the same time visited the Jahrhundertausstellung, which, under Tschudi's direction, gave a broad view of twentieth-century German painting. But these short journeys merely interrupted his continuous work in Berne, work through which he kept widening his artistic horizon, not just through painting and drawing, but through literature and music.

In the autumn of 1906 an important change took place in his life. He married Lily Stumpf and settled in Munich, the city where his artistic education had begun, and where he had held his first exhibition—etchings—in a one-man show, also in 1906. It was to be his home until 1920, and from the first Klee supported himself and was independent of his father. In 1907 his son Felix was born and this gave his family life a new meaning. Klee divided his time between his home and his work, while his wife earned what the family needed, particularly by giving piano lessons. Klee was gradually becoming known: in 1908 he had shows of his works in Berlin and Munich; in 1910, a show of fifty-six of his works, first at the Kunsthaus in Zurich, then in Basle, Berne and Winterthur; in 1911, at the Tannhauser in Munich, the first collective exhibition of his work appeared, and this brought him into touch with the group of artists who, in the same year, were to come together in the Blaue Reiter.

The years he spent at Munich not only made Klee known for the first time,

Figs. 1-3

but had a profound influence on the way his style evolved. New possibilities appeared to him in particular through his discovery of the Belgian painter James Ensor. In 1909 a friend gave him a drawing by Ensor which he particularly admired. Several exhibitions in Munich also widened his horizons and made a deep impression on him: the two Van Gogh exhibitions in 1908, and a one-man show of Hans von Marees in the same year, and in 1909, exhibitions of Cézanne and Matisse at the Tannhauser. Klee's diary for those years shows that he was not interested only in figurative arts, however; music and literature were also important to him, and in 1911 he illustrated Voltaire's *Candide*. This year, 1911, changed his life in Munich in several Fig. 5 ways. He met a number of artists of the Blaue Reiter group—first Kubin, who visited him at home and felt a great admiration for his work, then Kandinsky, Macke, Marc and the rest—so that he felt accepted in advanced intellectual circles. It is clear that at this time he became aware of his own artistic identity and importance, because in 1911 he began to make a catalogue of his works, going back to his first successful studies in 1899. In the years that followed he had exhibitions in Switzerland and took part in the famous Sonderbund-Ausstellung in Cologne, and in the second Blaue Reiter exhibition in Munich. In 1913 his work was shown at Der Sturm in Berlin and at the Ersten Deutschen Herbst Salon. But before that, in 1912, he acquired valuable new impressions from the exhibition of the Futurists at the Tannhauser in Munich, and in the same year, during a short springtime visit to Paris, he met Robert Delaunay, daring exponent of a remarkable form of Cubism, as well as Daniel-Henri Kahnweiler, Picasso and Braque's dealer, champion and theorist of the Cubist style. He also visited Wilhelm Uhde, expert in German art, who was renowned in Paris for his discovery of the paintings of the Douanier Rousseau. At Kahnweiler's, Klee saw paintings by Picasso and Braque, at Uhde's, works by Rousseau; and with Delaunay he had long, serious talks on the theories and techniques of these painters. In 1912 he translated Delaunay's essay *On Light* into German, and in 1913 it was published in the newspaper *Der Sturm*. But, although the years 1911 and 1912 were a lively and fertile period in Klee's life, all these impressions, all these exchanges of ideas, seem to have had little influence on his work; indeed, it is hardly ever possible to talk of definite influences upon it, because the impressions he received from works of art, either from the past or from his own time, had to develop in his mind until they acquired a meaning in his own terms. This certainly happened as far as his discovery of Delaunay's work and chromatic Cubism in 1912 was concerned; it was only when he went to Tunisia in the spring of 1914, with Auguste Macke and Louis Moilliet, that all he had seen, learnt and assimilated in Paris appeared. The journey was short: it lasted only from April 5th–22nd. On April 5th, Klee left Berne with Moilliet, passed through Geneva and Lyons to Marseilles, and there met Macke and set sail for North Africa. On April 7th, they landed in Tunisia, and spent April 11th, Easter Sunday, in the country house of a Swiss friend, Dr Iaggi, at Saint-Germain, a garden city. From there they visited the ruins of Carthage and Sidi-bou-Said, and went on to Hammamet. On April 15th, the three friends were at Kairouan, the country's ancient and venerable religious city, and it was here that the seeds sown during the preceding years began to germinate.

Klee wrote in his diary: 'Colour possesses me. I no longer need to seize it, it possesses me forever, I know. This is the revelation of this happy time: colour and I are one. I am a painter.'

After this revelation, Klee hurried home. On April 19th, he landed in Naples, alone, because his two friends wanted to stay on in Tunisia. From Naples he went through Rome, Florence and Milan, to his birthplace, Berne, on April 22nd, and three days later he was home in Munich. Here he plunged into his work, and in the months that followed gathered the harvest of many years.

On August 1st, the First World War broke out, but even this overwhelming event had scarcely any effect on his inner life. The war affected

him through his friends, of course: Kandinsky went back to Russia, Jawlensky went to Switzerland, Gabriel Münter left Germany and went to Scandinavia, Macke, Marc and Campendonk were called up, and so were many French friends.

On September 16th, 1914 August Macke was killed at Perthes; he was the first of Klee's close friends to die in the war, and Klee was deeply shocked by it. But during 1915 he continued to work. In the summer he went to Switzerland on holiday, and there made some of the best drawings of this period. At the end of the year Franz Marc was back in Munich, on leave from the front. Klee met him for the last time, as on March 4th, 1916, Marc fell at Verdun. What this loss meant to Klee is shown by a sentence in his diary: 'Sometimes I remember the name Marc; I am shaken, and see things crumble.' A week after Marc's death, Klee, who had German citizenship, was called up.

Army life did not prevent him from working, and a man of thirty-seven was not expected to do a great deal. He began his military service in the recruiting office at Landshut, and in November was transferred to Schleissheim, where he was set to painting aeroplane wings. The war had at first seemed to him a 'fantastic dream'; now it was a strange adventure in which he continued to paint, play music regularly, and, during trips he made in connection with his army duties, visit museums in the towns he went through. In January, 1918, he was given a new job as clerk at Gersthofen, near Augsberg, and here too his work allowed him to continue painting. During these final wartime years he read a great deal, and tried to arrange his thoughts on fundamental issues: art, the world, life. This time of reflection and introspection became the basis of the next phase of his life and activity. Appreciation of his work by influential critics like Daeubler and Hausenstein, and the respect of his army superiors, gave him a feeling of his own merit. In the last year of the war, fifteen of his drawings appeared in the album 'Sturm' and he wrote the essay 'Schöpferische Konfession', in which he looked about him and examined the years of meditation and experiment; it appeared later, in 1920.

Around Christmas, 1918, the war was over for Klee and at last he was, once again, fully what he had never ceased to be during his time in the army–a free artist. He went back to Munich, where he worked intensively and fruitfully, with a long holiday in Switzerland. During the war his work had increased a good deal in value, and he decided to sign a contract with the art dealer, Goltz, first for three years and then for a further three, until 1925. The first result of this contract was a large exhibition of Klee's work, which Goltz put on show in his own galleries in Munich. The catalogue, which appeared in a special number of the newspaper *Der Ararat*, lists 362 works, and gives a clear picture of Klee's activity. Among avant-garde artists and intellectuals the exhibition aroused admiration, indeed it made Klee famous. In the same year, 1920, the essay 'Schöpferische Konfession', which he had worked on in 1918, was published, and so were the illustrations for Voltaire's *Candide*, which he had made in 1911–12. But what above all made his name famous were two monographs on his work, one by H. von Wedderkop and the other by Leopold Zahn. In 1920 these exhibitions, publications and monographs made Klee seem one of the most eminent artists of the modern movement in Germany, and at the end of the year he was finally established in the German world of art when, on November 25th, he was invited to the Bauhaus in Weimar, founded in the previous year.

The telegram Gropius sent him on behalf of the Bauhaus committee read: 'Dear, illustrious Paul Klee, we all invite you to come to us at the Bauhaus, as a painter–Gropius, Feininger, Engelmann, Marcks, Muche, Itten, Klemm.'

Without hesitation Klee accepted, and a new phase began in his life and work. He took his responsibilities as a teacher very seriously and felt he must consider and put into practice his ideas on art in general and painting in particular, both as a technique and as a creative act. In the years that followed

he continued to clarify his theories, not in a fixed pre-established form but as a synthesis of everything his painting had led him to, and of all it had resulted in.

In January, 1921, Klee moved to Weimar, and after the summer holidays his wife and Felix followed. For ten years, until April 1931, he stayed at the Bauhaus, dividing his time between painting and teaching. Each summer he went abroad: in 1923 to the island of Baltrum in the North Sea, in 1924 to Sicily and in 1926 to Italy, particularly Florence and Ravenna; in 1927 to the island of Porquerolles and to Corsica, and in 1928 to Brittany; that same year he took a winter trip to Egypt as well. In 1929 he was in the Basque country, between France and Spain; in 1930 in the Engadine and on the Italian Riviera. All these journeys were not merely events in his life but were always reflected in his work, even if not right away.

Through exhibitions and publications, Klee's fame was spreading from provincial Weimar to the rest of the world; in 1921 Wilhelm Hausenstein's monograph *Kairuan oder eine Geschichte von Maler Klee und von der Kunst unseres Zeitalters* (Kairouan or a story of the painter Klee and the art of our century) made Klee's work known outside the world of avant-garde painters. In the Bauhaus itself, the big exhibition of 1923 showed Klee's work and his position in his circle of friends and pupils, and in the same year an exhibition in the Kronprinzepalast in Berlin once again showed his work to the capital. Klee's essay 'Wege des Naturstudium' (Ways in which to study nature), a part of his own story, appeared in the same year in *Staatliches Bauhaus in Weimar, 1919–1923*, and in the following year Klee gave a lecture at Jena setting out his fundamental ideas. This was not published until 1945, but it contains the basic theory which lies behind most of the art of the twentieth century.

In 1924, Klee's first exhibition was held in America, organised in New York by Catherine Dreyer. In the same year, the Bauhaus in Weimar was finished; Gropius's institute was banned by a narrow-minded local authority, and forced to leave Weimar and start up elsewhere. At the same time the group Die Blaue Vier was formed, linking Kandinsky, Klee, Feininger and Jawlensky. In this, his last year at Weimar, Klee was visited by Leon Paul Fargue, who considered having a German translation of his poems published with a selection of Klee's drawings, an idea that was not realised however.

In 1925 the Bauhaus moved to Dessau. Klee stayed on in Weimar for a short time. But the heroic years of the Bauhaus were over, and a new phase was to start in Dessau, inspired by Gropius's new motto: 'Art and technique, a new unity'. In the first year at Dessau Klee's *Pädagogisches Skizzenbuch* (Pedagogical sketch-book) was published in the Bauhaus series of books, texts that are fundamental to an understanding of the new art. In the same year Klee had a new show in Paris, at the Vavin-Raspail gallery, and was represented in the great exhibition of Surrealists, organised by André Breton. In 1926 Klee and his family moved to Dessau, to one of the new houses which Gropius had designed for the Bauhaus teachers. Here, one of his neighbours was Kandinsky, who had been teaching at the Bauhaus since 1922 and was a friend whom Klee respected. The teaching and example of the two of them pointed out a new way ahead to the next generation, and thus influenced in a decisive way the road which painting in the second quarter of the twentieth century was to take.

The next important event in Klee's life was the trip to Egypt, which took place at the end of 1928 and the beginning of 1929. It was short, like the one he had taken to Tunisia in 1914, lasting from December 17th, 1928, to January 17th, 1929. Here, once again, Klee found some of his ideas confirmed, and the results appeared in his work during the following year. In 1929, Klee was fifty. To celebrate his birthday the Flechteim gallery put on a large exhibition of his work in Berlin. This wide-ranging show, together with Grohmann's monograph which was published in French by Cahiers d'Art at the same time, gave a striking picture of Klee's contribution to modern art.

Meantime, Klee had reached a new phase in his development, elaborating the ideas he had brought back from Egypt in paintings and etchings in which space was shown through lines, and the structure was extremely precise. Flechteim's exhibition was transferred to New York in 1930, and Klee's work was shown in the Museum of Modern Art as one of the most important and radical contributions to modern art, and, more important still, as 'a window for a new concept of the world'. At about the same time, exhibitions of his work were held in a number of German cities, and his fame as an innovator was increasing. Klee himself was putting his ideas of space into practice. After a trip to the Engadine and the Italian Riviera he produced the first paintings which added a new meaning and a new, non-naturalistic purpose to the technique of pointillism: colour became light, and light now became space.

In 1931 contemporary events, which Klee had so far managed to keep at a distance from his life, began to interfere with it. At the Bauhaus, the hostility of the Dessau Institute repeated what had happened at Weimar, and forced Klee to leave and accept an invitation to teach at the Academy in Düsseldorf. His life was now altered. He lost the close collaboration of Kandinsky and Feininger, but met another colleague from the days of the Blaue Reiter group, Heinrich Campendonk. At Düsseldorf, Klee's arrival was helped by the fact that a large exhibition of his work was being held at the Kunstverein, and provided an introduction for him.

But Klee was not to work there for long; the rise of National Socialism and Hitler's assumption of power meant that no great artist, however silent, could escape. Klee was among the first to be criticised by the Nazi regime, in April 1933. In December of the same year he left Germany for good, and returned to his birth-place, Berne. The years in Berne – from the end of 1933 until some time before his death in 1940 – were decisive for his inner development, for he was no longer tied to teaching, no longer felt any external pressure. He now had the freedom he had so long desired, although, ironically, he owed it to the triumph of slavery in Germany. The way in which he used this freedom was characteristic of him.

In Berne, he looked back at the work of the preceding years, considering it as an organic whole and so 're-elaborating' it in its entirety, like a writer reshaping his work for a new edition. He added, improved, and rounded it off clearly. In other words, he put his early work in order – the order he had always meant it to have.

This was all perhaps due to certain events: firstly, to the publication of Klee's drawings from 1921 to 1930, in an edition prepared by Grohmann, and at the last minute seized by the Gestapo; secondly, the preparation of the large one-man show that took place at the Kunsthalle in Berne in 1935. Klee was busy preparing for this exhibition for a long time before it came on, and while it was open, he did practically no work. In 1935 his activity began to slow down for another reason. In the summer of that year the first symptoms of his illness appeared, an illness that was to undermine his capacity for work and finally to prove fatal in 1940.

In 1936, although he fought bravely against its advance, he managed to produce very little. When he began work again in 1937, his style, his whole manner had changed. The drawing, and the gaiety in it, had disappeared. The choice of subjects and symbols had also changed – they were now full of tragedy. His own advancing illness can hardly have accounted completely for the change. The fate of Europe, the fate of art in Germany, may well have explained this sudden change to the tragic, particularly because it was of such personal concern to Klee. In the exhibition of degenerate art, put on in Munich in 1937, in which every form of art that did not conform to the Nazis' blind dogmas was shown, Klee was represented by seventeen works; and when the German museums were purged, 102 of his works were confiscated by the state. Klee said nothing about this, and the silence of his despair is quite understandable.

But 1937 brought him something positive as well: three great painters of

his generation, Picasso, Braque and Ernst Ludwig Kirchner, visited his studio, and were able to see for themselves the final products of Klee's work. These visits gave Klee himself a sense of being appreciated by the contemporaries whose work he most admired, and of being able to consider himself on their level.

In the last years of his life Klee concentrated almost exclusively on his work; he scarcely ever left his studio, except when it was necessary on account of his illness. He made an exception in 1935, when works from the Prado were shown in Geneva, and for the first time he was able to see, with enthusiasm, the work of the great Spanish painters, as well as that of Bosch, Breugel and Mantegna. Apart from this short trip, he stayed at home, but his work went round the world. In 1938 he had an important part in the Bauhaus exhibition in New York, and had two one-man shows in the same city as well; and Kahnweiler, who represented Klee's interests in Europe, showed his paintings at two exhibitions in Paris.

During this period, before and after his sixtieth birthday, Klee painted his last pictures, which are dominated by figures of angels that seem to foreshadow the next world. Early in his illness, Klee always hoped for a cure, and even made plans for paintings, journeys and publications, but once he was sixty there were much clearer signs that death was approaching. In the spring of 1940, a large exhibition at the Kunsthaus in Zurich summed up the work of his final period, from 1935 onwards. Klee's last paintings were done at the same time as this exhibition. On May 10th, the day on which Hitler invaded France, Holland and Belgium, he went into a nursing home at Locarno-Orselina. Shortly afterwards he was sent to the clinic of Muralto, where he died on June 29th, 1940. On his gravestone in the cemetry at Schosshalten, in Berne, his own words are carved: 'In this world I cannot be wholly understood. So I am better among the dead, or among the unborn. Closer than most to the centre of creation. But still not close enough.'

The first works mentioned in the catalogue which Klee began to draw up in 1911, and afterwards kept carefully up to date, are from 1899. In 1899, he concentrated entirely upon drawings and etchings, partly because he was quite sure that quality appeared when conscious limitations were placed upon an artist's way of working. In 1910, he exhibited a collection of his graphic works for the first time. So the period in which he concentrated exclusively on graphic work came before the catalogue was prepared. As the spirit of the time – the beginning of the twentieth century – suggested, and in accordance with the tastes of his master, Franz von Stück, and his great idols, Blake, Goya, and Beardsley, he chose line as the essential means of expression. The predominance of colour was confirmed in contemporary art, and above all in German art, only later, after 1906.

Klee as designer and engraver, 1899-1914

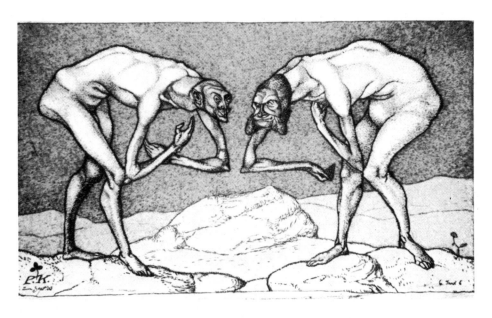

1 *Two men meet, each supposing the other to be of higher rank* ('Invention' 6) 1903, etching $4\frac{1}{4} \times 3\frac{1}{2}$ in (11 × 9 cm)

2 *Virgin in a tree* ('Invention' 2)
1903, etching
$9\frac{1}{8} \times 11\frac{1}{2}$ in (23·5 × 29·5 cm)

Fig. 2 Klee's first etching, *Jungfrau im Baum* (*Virgin in a tree*), from 1903, or
Fig. 3 *Komiker,* I (*Comedian,* I) from the following year, are in some ways con-
nected with late nineteenth century symbolism. The fusion of the human
figure with the almost Japanese form of the tree, realised as an arabesque, in
the *Jungfrau im Baum*, recalls, in its style, the Jugendstil drawing of the period.
But an engraving like *Komiker*, which Klee himself mentioned with satis-
faction, shows the personal way in which he conceived both its contents and
its form. It achieves an effective sense of reality and the artist's humour is
perfectly suited to show the inner conflict of the image in the contrast
between black and white.

 The expressive strength of Klee's line, and its often biting sarcasm, are
Fig. 1 also shown in the etching *Zwei Männer einander in höherer Stellung vermutend,
begegnen sich* (*Two men meet, each supposing the other to be of higher rank*)
from 1903. In this it is clear that, stylistically, Klee belonged somewhere
between the English 'decadents' and the German illustrators of *Jugend* and
Simplicissimus. With both he shared the urge to load line with symbolic and
allegorical content. But during these years Klee realised that the most im-
portant part of his development would be in the elaboration of style rather
than content, and that, as his style matured, it would reveal itself for what it
was and give meaning to the whole work.

 In the years after 1905 the discovery of a new technique helped him to
perfect and develop his graphic style: this was painting on glass. The tech-
nique, which has popular roots and still persists in parts of the Bavarian Alps
and in Austria, was a revelation to Klee because of the possibilities it offered
him. He did various experiments, starting with graffito on strips of blackened
Fig. 4 glass, or else with a white strip on a dark background. *Bestie, ihr Junges
säugend* (*Animal suckling its young*) from 1906, and *Strasse mit Fuhrwerk* (*Road
with a car*) from 1907, are two examples of this development, which led
Klee on to a rather pictorial technique, and so to re-elaborating his graphic
techniques; the difference between the single, unified line, and the tangle of
many lines, provided him with new opportunities, in particular because of
its contrast with visible reality.

 This contrast was very clear right from the early years, in which he made

etchings full of strange allegories. Several magnificent drawings from the years that followed show the way his search was proceeding. Sketches like *Schafe in der Hürde* (*Sheep in the stable*), from 1908, and drawings of the main square in Munich or of the confusion of wheels in the main station show in what way he was trying to unify this multiplicity and bring order to this confusion. He did not do this by making a strict choice or rationalising what he saw, but simply by translating all the data of reality into his language of line, uniting strokes and lines, and making the whole visible world be born in them and through them. Klee's graphic methods had by now been developed enough to show his own concept of the world, and he began the illustrations for Voltaire's *Candide*, which he had had in mind since 1906, but which he began only in 1912. At this time he wrote (and the remark shows his conflict with the world, and not merely the world of figurative art): 'What should an artist be: poet, naturalist, philosopher.' With his illustrations for *Candide* he sought a point of contact between reality and art, knowing that his mastery of graphic techniques had made him able to find it. With the twenty-six pen drawings he followed the action of Voltaire's novel, which is so full of subtleties, recalling those Klee had sought to express in his early etchings.

These drawings, in which he uses 'signs' quite clearly and precisely, have another characteristic: the importance Klee gives to movement, not just to movement in relation to the contents of the drawing, but to movement showing the difference between fact and action. As far as this was concerned, Klee might have been influenced in those years by the Expressionists who were soon to become close colleagues of his in the Blaue Reiter and whose point of departure was action and drama, not fact. In the Expressionist poetry which was being written at almost the same time, this break with tradition was clear in the dominant use of the verb, expressing action.

Klee was to reflect long and carefully on the problems of movement. In his 'Schöpferische Konfession' (Creative confession), written in 1918 but describing the experiences of earlier years and published only in 1920, he says: 'Movement is fundamental to becoming. In Lessing's *Laocoon*, which bewildered us when we were young, great importance was given to the

4 *Animal suckling its young*
1906, painting on glass
$5\frac{1}{8} \times 7$ in (13×18 cm)
Felix Klee collection,
Berne

difference between art in relation to time and art in relation to space. And when you look at it more carefully, this art appears to be nothing but a scholarly illusion. Because space is also a concept that is relative to time. If a point becomes movement and line, that takes time: the same thing is true for a line that defines a plane. The same thing is also true for the movement of planes that define spaces. Is a plastic work born in a single moment? No, it is built up bit by bit, like a house.' This emphasis on construction, on movement in the dimension of time, can already be clearly seen in the illustrations for Voltaire's *Candide*.

Klee could thus clearly show this movement, this 'building up bit by bit', because he had totally mastered the principles of graphic art. The words he uses to describe the process of movement in the essay quoted above show what he meant. At the beginning of the essay Klee defines his thought on the creative graphic processes in this way: 'The essence of graphic art leads easily and rightly to abstraction. The uncertain, fairytale features of imaginary characters are facts and, at the same time, they appear with great precision. The purer the drawing, the more important the elements of its

form, and the more imperfect the effort to represent the visible world realistically must be. Elements of drawing are: dots, linear, plane and spatial energies. A plane element, which is not composed of underlying unities, is, for example, an energy without variation produced by a large dot. A spatial element is, say, something pale and light, like a cloud, produced by a brush of various sizes.

'I have called elements of drawing those which must visibly form part of the work. This demand does not mean that a work must be composed only of elements. The elements must produce forms without sacrificing themselves, indeed by preserving themselves.

'Several elements often have to join together in order to give origin to forms, subjects, or other secondary things: that is, planes composed of lines in relation to one another (for instance, choppy flowing water), or structures of energy in the third dimension (fish swirling confusedly about).

'Thanks to this enrichment of forms, the chances of variations are infinitely increased, and so are the chances of ideal expression.'

This could almost be a description of the drawings for *Candide*. The statement: 'The uncertain, fairytale features of the imaginary character are facts, and at the same time they appear with great precision,' emphasises the objects of the series of drawings in the same way that they suit the words and actions of Voltaire's novel. Although Klee confined himself to graphic elements in the essay, it is clear that he felt the origin of forms was important; he himself liked to call them 'genesis'. The figures of these illustrations are composed of lines, both moving and still, but the lines are reborn as well – reborn as energies, as pieces of canvas, which either carry them ahead or hold them back. This almost seems to anticipate the discoveries of physics, to suggest nuclear elements and their energy, in the same way that one might anticipate the development of figurative art by taking the illustrations and comparing the figures drawn by Klee in 1911 with the sculptures of Giacometti in the years after the Second World War.

Klee's graphic work of these early years, and the way he described it in his essay of 1918, make it clear that this period was extremely important in his creative life.

Admittedly, in these etchings and drawings he had not yet mastered his techniques completely, and was not yet making use of colour and all its rich possibilities. As a painter, he was still undeveloped, but as an artist he was in these engravings already mature.

When he began to study art, Klee had decided to confine himself first of all to mastering the technique of figurative art, and to him this technique was represented by graphic art. Perhaps his musical education influenced this early decision, and made him feel that the mastery of a single instrument – say the violin – was the basis of every creative process, and that only through an instrument could the principles of composition, harmony and form be understood and mastered. In this way too his work can be said to have been born 'from the spirit of music' (to paraphrase Nietzsche).

Like many musicians, Klee started with works which can be compared to chamber music, but the principles of composition that were to remain constant in the richly orchestrated works of his maturity were all present in his youthful works. Klee acquired them by listening patiently and conscientiously to the pure sound of his instrument – graphic art. Contact with the painters of the Blaue Reiter, especially Kandinsky and Marc, revealed the fascination of other instruments to him, but Klee already knew that his work must mature, and that he could not force the organic maturing of his own personality. 'Maturity must not come quickly, when so much is sought.' What he could do was 'cultivate his garden' (*Candide*), and this was exactly what he was doing.

The painter in Klee came to life in the spring of 1914, in the hot southern sun. He himself was completely aware of this fact and wrote in his diary: 'Colour possesses me. I no longer need to seize it, it possesses me for ever, I know.

Klee as painter, 1914-1920

This is the revelation of this happy hour: colour and I are one. I am a painter.'·

The southern sun was what in fact made Klee a painter, the sun that suddenly opened the closed bud. But this sudden revelation had long been prepared for, as Klee matured. As early as 1910 he had written: '. . . to be able to let my imagination wander freely over the keyboard of colour, among the pots of watercolour set up in rows'. Kandinsky, in the same period, had several times used piano keys as an image of the effect of colour in his book *Über das Geistige in der Kunst*. At that time, Klee felt that the composition was less important than free imagination, that is, the form derived from music which he often called 'psychic improvisation'. The noisy orchestration of Kandinsky's colours in the paintings and watercolours of the Blaue Reiter period aroused profound admiration in Klee (an admiration which he expressed in an essay published in *Die Alpen*, VI, 1911–12), but he did not feel mature enough yet to test himself as a painter. The meeting with Robert Delaunay in the spring of 1912 must have given him further ideas about it. At about that time, Delaunay had developed a variant of Cubism, the object of which (no doubt in the wake of Seurat's discoveries and the Neo-Impressionists' use of colour) was to represent not volumes but light and colour, as Picasso and Braque had originally done. Klee wanted to apply the method of Cubism to colour. As the Cubists and Klee broke up the form which was composed of its own components, so Delaunay dissolved sunlight into its components, that is, into the colours of the rainbow. From light, colour was born, and from the succession of colours and their spatial properties movement was born.

Klee knew of Delaunay's principles, and when he visited his studio in Paris saw some of his Orphist works. In the autumn of 1912 Klee translated an essay by Delaunay on light and colour, and this was published in *Der Sturm*, Herwath Walden's newspaper, in Berlin, the following year. But Klee did not draw conclusions about his own art from those of the essay; colour was foreign to him until his journey to Tunisia, and although he sometimes used it in his work before 1914, as for instance in a small oil painting *Mädchen mit Krügen* (*Girl with jars*), in 1910, he considered it more for its 'values', as one might consider musical notes, rather than as being in any way essential to the picture. His pictorial use of colour came only after it had been developing for a long time – on account of the Tunisian sun. The blinding light of the south made him see colours and feel their 'sounds': 'Green-yellow, terracotta. The sound penetrates deeply and remains there, even without painting in time and space.' The first works in colour from Tunisia are watercolours; this is significant, because the white of the paper shows through the thin layer of colour and gives it a particular strength and luminous quality.

These first Tunisian watercolours, which were followed by some superb sketches of Hammamet and Kairouan, almost immediately showed Klee's pictorial style in colour. The reality he had seen in Tunisia, the colours and forms, were a revelation to him because he now really saw coloured and concrete figures before his eyes, where before he had seen them only in his mind. It was a revelation, then – but a confirmation as well. Characteristically, colours and forms right from the start were arranged rhythmically, so that they could be used to represent things, not as a mere property of them. As Klee had already said in his essay in 1918: 'the elements must become forms without sacrificing themselves, indeed by preserving themselves.'

In these works, then, we find the difference from Analytical Cubism, which Klee, in that same year, 1914, praised in his *Homage to Picasso*. Klee did not break things up into their elementary forms, but, like Juan Gris, composed things out of elements that 'offered' themselves to him while he was working. Two fine examples of this method of creation are *Rote und Weisse Kuppeln* (*Red and white cupolas*) and *Motiv aus Hammamet* (*Motif from Hammamet*). The two works show clearly that Klee was not interested in merely reproducing objects, but that the structure of forms became his means of achieving a richer, freer concept of reality. Besides, this new

Fig. 6

Fig. 7

6 *Homage to Picasso*
1914, oil on canvas
15 × 11¾ in (38 × 30 cm)
private collection,
Basle

interpretation allowed him to let his imagination 'wander freely over the keyboard of colour, among the pots of watercolour set up in rows'.

The visit to Tunisia determined the course of Klee's activity for many years. The main thing it brought his work was this sense of the importance of colour. A watercolour like *Der Niesen*, from 1915, shows the evolution and maturity of Klee's style; forms and colours penetrate one another to produce figures. Blue is identified with the form of the triangle to produce the noble hill that rises splendidly from the small forms in the foreground. This work is also important in so far as Klee's forms are concerned because it shows how a large motif, the blue triangle of the mountain, achieves its particular quality by being set beside minor rhythms; in music, especially that of Mozart, Klee's favourite composer, one particular theme is accompanied by all kinds of minor ones, and for this very reason it becomes important.

Fig. 8

In many of his works painted during those years, as in this picture, there are echoes of the effect Tunisia made upon him: an architectural subject suits the architectural image, as in *Bewegung gothischer Hallen* (*Movement of Gothic porticoes*), or *Steinbruch Ostermundigen* (*Stone quarry at Ostermundigen*), both from 1915. In these watercolours Klee clearly let himself be influenced by architecture and thus expressed the architectural principle of Cubist paintings–which was also that of Cézanne. To Klee, architecture meant structure, and so it meant the genesis of forms from elements. He tried to use this principle for the first time in Tunisia, and in his work in the years that followed he managed to use it more freely, thus becoming independent of his subject.

His maturity meant just that: an ever freer relationship with visible,

perceptible reality, defying the bounds of mere representation.

Klee's work did not evolve in a single direction, however. It was typical of him that while he was advancing in one way, he might, in another, be returning to an earlier phase. Old and new themes overlapped, enriching one another all the time. Often he went back to his earlier drawings, and at the same time he might consider his 'Cubist' experiments once again. The result was that he achieved a sign language which grew progressively further from visible reality, but always indicated a reality. Typical of Klee's work during this period were his drawings of letters, which gave a visible, solid form to his theme, just as in songs, from Schubert to Hugo Wolf, they give form to a musical portrait. So, by treating formal elements freely in this way, and by inventing signs that gave form to what was essential in nature without reproducing its appearance, Klee developed a sign language that became for him the key to reality. An example of this method of free imagination is his *Invention mit den Taubenschlag* (*Invention with a dovecot*) from 1917. In this Klee produced, out of rhythmically arranged coloured triangles, rectangles and circles, architectural images that, as he made them, suggested a dovecot. It was characteristic of Klee that when something was offered to him from the world of objects he should accept it and perfect the idea as a symbol for his own figures.

Fig. 9

To enrich his own sign language, Klee widened his technical methods as much as possible. Will Grohmann, who made a penetrating study of Klee's techniques, found that he had made many discoveries in connection with painting techniques, and constantly found new variations for them; he might have a plaster base or a mixture of oil and watercolour, and bases of paper, cardboard, muslin or sacking. The sign language was closely connected with

7 *Red and white cupolas*
1914, watercolour
$6 \times 5\frac{1}{2}$ in (15·5 × 14 cm)
Clifford Odets collection,
New York

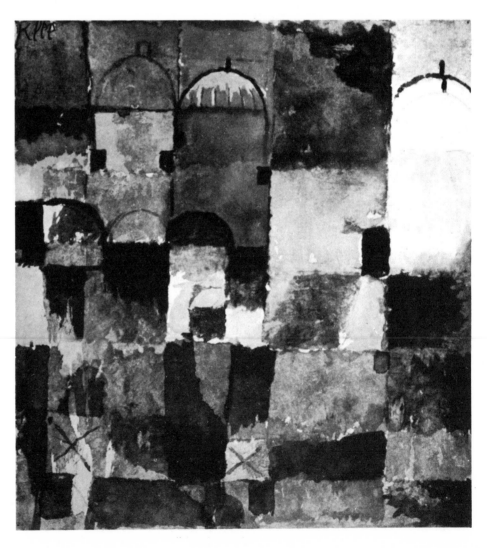

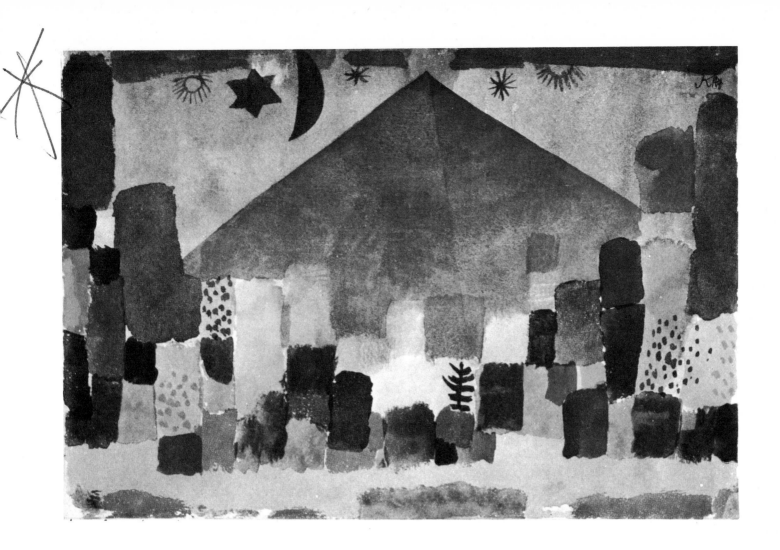

8 *Der Niesen*
1915, watercolour
$7 \times 9\frac{3}{4}$ in (18×25 cm)
Hermann Rupf collection,
Berne

the technique he was using, and so the technique was very carefully used. At first sight, Klee's painting might seem haphazard and amateurish, but in fact it was done with great care and did not change or deteriorate. The improvisation Klee often spoke of as the principle of his creativity was not material but spiritual: it was a 'psychic improvisation', while the material creation of his work was based on strictly technical principles. Grohmann wrote that Klee's studio was like a chemist's shop. It was important for him to have at hand all the materials he needed for his technical experiments. The technical structure of his painting might lead to new relationships and enrich his vision of the world, and this was Klee's object.

It was at about the same time as the paintings influenced by his journey to Tunisia, and as the 'cosmic images', that he wrote the essay 'Schöpferische Konfession', in which he explained the basis of his art and the main qualities of his work. The essay dealt with a fundamental theme of great importance to twentieth-century art in general: 'Art does not show the visible', he wrote, 'but makes it visible'. With this statement Klee announced the course of his future work: art had a new function and at the same time rejected its old one – the representation and perpetuation of the reality that could be seen. Its new task, the representation of a reality that was not yet visible, made figurative art the key and the most important means of expression of a new vision of reality, a vision that might also be an interpretation, and for which the term 'vision of the world' seemed exactly suited.

In his essay Klee elaborated this idea. 'Before, things which were visible on earth were described, things which either people were glad to see or would have wished to see. Now, the reality of visible things has spread, and there is a widespread, absolute conviction that, in relation to the whole of the universe, what we can see is only an isolated part of it and there are other infinite truths, hidden and greater. Things have acquired a wider meaning, compared with our previous, rational experiences. We try to make the fortuitous essential.' This corresponds with the entry in his diary on July 17th,

1917: 'All that is transitory is only an allegory. What we see is a proposal, a possibility, a help. Real truth lies on an invisible foundation.' In this definition of painting, Klee seriously asks his old question: What should an artist be: poet, naturalist, philosopher.' It was not enough for him, as it was for so many in his time, to paint pictures that enriched art; he wanted to plumb reality in his work, and to give it meaning and content. What he was seeking went beyond the limits of aesthetics and of the artistic, to find its real sense in the field of religion. At the end of the essay Klee wrote: 'Every energy demands a complementary one in order to achieve a state of stillness in itself, strung as it is between opposing forces. In the end what is created is a cosmos of abstract formal elements in union with concrete beings or abstract things like numbers or letters, a cosmos so like the great creation itself that sometimes all it needs is a breath to make it become religious expression, the true religion; art behaves symbolically towards creation. Art is thus a symbol, as earthly things are a cosmic symbol.'

How is the great design of the world's new image shown in Klee's small works, and how are they produced? As an example, let us look at two from Pl. 4 1919 and 1920, *Villa R* and *Kamel in rhythmischer Baumlandschaft* (*Camel in a landscape of rhythmic trees*). In both these paintings the process of dialectical

composition which Klee describes in his essays appears: 'Every energy demands a complementary one in order to achieve a state of stillness in itself.' In the structure of the forms, as in the range of colours, there is always thesis and antithesis: the architectural cubes of Villa R against the spatial stretch of path, and the flat form of the letter, and over all this the form of the mountains and clouds with the sun and crescent moon as cosmic and geometrical contrasts. In the painting *Camel in the landscape of rhythmic trees,* a contrary process takes place: from the rhythms formed by the trees, the signs of the trees with their rounded tops and straight trunks, the camel is born of itself like a puzzle, like another sign. What the two paintings have in common is the fact that they are both landscapes of the world: no longer strictly topographical representations of the real landscape, but, as the art of landscape was in the beginning, ideas of the 'great creation' and of its breathing.

As in his early work, Klee produced a cosmos of abstract elements, but here they are richer and firmer. By discovering the possibilities that colour gave him Klee moved from chamber music to symphonic composition. But his composition was still subject to the same laws and still had the same object. Klee had called his first etchings 'Inventions', which meant he had wished to pass on an allegorical symbolic message. He used the title again in 1917, *Invention with a dovecot,* and the intention is the same.

In his first etchings Klee had already used forms in a way that went beyond the meaning of the forms themselves. What lay beneath his youthful drawings, which were still humorous in a restrained way, showed his artistic objective from the very beginning. In his mature work Klee managed to make his forms and colours have no other meaning (no allegory, that is) but become so rich and varied that they contained the allegory of another reality. As the years went by Klee's world of forms and his creative process became open to larger interpretations; he took on more and more plans and possibilities. In the course of a few years he had switched from graphic art to painting, and had enriched his work with colour, but he remained faithful to the law which he had accepted.

When, in December 1920, Klee received the telegram from Gropius and the council of the Bauhaus asking him to come there as a painter, he not only knew that he was one of the most creative painters of his time, but he was also aware of the world of figurative art. This was not just because his paintings were formally rich, strictly yet variously composed; it was, above all, because of the depth of meaning he gave them. He himself wrote in 1918: 'Behind the variety of interpretations there is a final secret, and the light of the intellect is wretchedly put out.'

When he went to the Bauhaus in Weimar, Klee's situation with regard to his own work underwent an essential change. Ever since he began working, he had taken no notice of anyone but himself in the creative process and in the manual techniques of his work. Now, when he began teaching at Weimar, he felt obliged to consider the basis of his own work, in order to be able to answer his pupils. 'Theory is a help to clarification,' he said. His theory of painting and form was wholly linked to practice; it was the product of work, as well as its result and commentary, and was intended to explain and hand on artistic values.

The artist as teacher, 1921-1933

Until then, Klee had noted down ideas and discoveries in his diary. These came to him in all kinds of ways, often from the subconscious. Now he wondered what they really meant and tried hard to see clearly the basis and the development of his work. Having to communicate clearly to other people, he felt it necessary to consider and to re-examine methodically what lay behind his work, so that his teaching at Weimar could be systematically arranged and highly disciplined. He made a plan, stuck closely to the courses he had prepared, handed out homework and discussed it with his pupils after a week.

In this way his teaching developed, and at least some important notes have been preserved in his *Pedagogical sketch-book,* which appeared in 1925 in

the series of Bauhaus books. Klee started from the elements, and his teaching was a development of the 'instructions on a formal plane' that had provided the basis for his own work. Elaborating his own teaching helped Klee to clear up many problems of his own work, and he always considered clarity the highest of qualities.

He did not consider that his teaching should deal only with painting; he felt it should be something that understood the world, its forces, laws and secrets; something that sought, not to reproduce reality, but to interpret it. Where his pupils were concerned, this was what Klee tried to teach. He was their example and their model, and his teaching was achieved only through explanation. Klee and the two painters who were his colleagues at the Bauhaus, Feininger and Kandinsky, were in agreement. Their work was the centre of their teaching, and served as an example to their pupils, for the Bauhaus did not seek to educate its students as the Academy did, forcing them to obey the master's rules, but let them find their own way by their own free creation. This was why Klee considered the object, rather than the result itself, important; 'Ways to study nature' is the title of an article in the Bauhaus newspaper.

Work was therefore at the centre of teaching, and the artist became a teacher in the widest sense that Klee meant to give the term: a teacher must help his students to find their own way through creation, and must not impose his own way upon them. He must not merely show his pupils how to paint an image; above all he must suggest that they ask themselves why images exist and perhaps even find an answer to the question.

In his own work Klee always asked this question, and during the years at Weimar he gave it a number of answers. First, the complex of questions was based on an awareness that figurative art could free man from the grip of true reality and show him the possibilities in other, wider, forms of being. If he recognised certain laws of creation, and acted according to them, man could himself become a creator, and art an allegory of creation; in it was found the unity between the vision of the world and the 'practice of art' which Klee so rightly taught his students.

For this reason there were compositions born directly from the creative elements at the centre of the work: 'The elements must give forms without sacrificing themselves, indeed by preserving themselves.' Here the theme of architecture which Klee had discovered in Tunisia, and varied many times with all the complexity of a rich metaphor, appeared quite clearly: 'Is an image produced from itself? No, it is built up bit by bit, like a house.'

Klee's Weimar paintings on the theme of architecture are also metaphorical variations on the theme of 'order' or 'composition'. Geometrical elements, like notes of different levels of sound, each of a different duration, form an order of changing density, understood as architecture only through certain touches (superimposed triangles and other things). It is not surprising that the architectural images of this period are so important in Klee's work. Architecture, or building, was at the centre of the intellectual world of the Bauhaus; it was 'the cathedral of the future', the dream which determined how Gropius's institute began and what it became.

These compositions of formal elements must not necessarily be interpreted as architecture to conserve their allegorical meaning. Under the title *Rhythmisches* or the simple description *Farbsteigerung vom Statischen ins Dynamische* (*Growth of colour from statics to dynamics*), 1923, they showed clearly how elements produced forms without sacrificing themselves. Clarity, the transparency of the composition, was again Klee's greatest objective, and it was because of this that these small works could become an allegory of the creation; an allegory, which, considering the variety and multiplicity connected with the word, meant a step forward from Klee's work as a young man.

The images on musical themes, like *Fuge in Rot* (*Fugue in Red*), are one of the most telling examples of Klee's art and of his vision of the world. Music, with its strict exactness of composition and structure, served the Bauhaus as

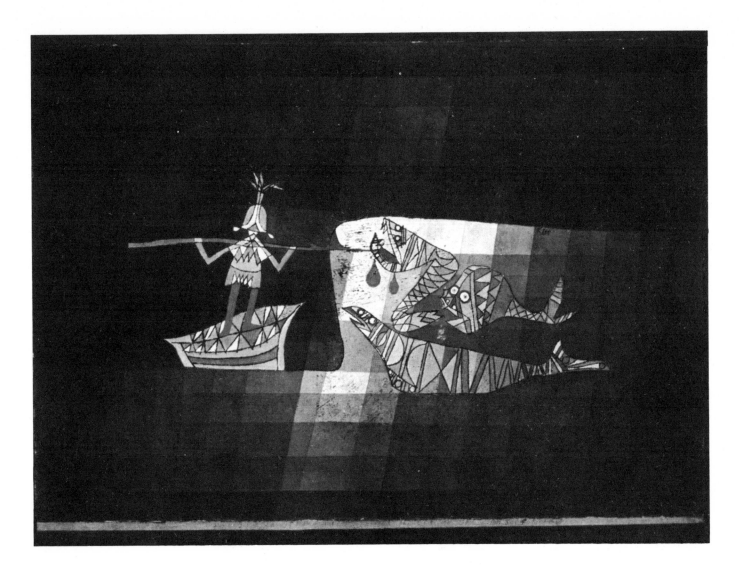

10 *Battle-scene from the comic fantastic opera 'The Seafarer'*
1923, watercolour and oil on canvas
15 × 20⅛ in (38 × 51·5 cm)
Madame Trix Dürst-Haass collection, Basle

a kind of model of architecture. At home, Kandinsky made music, and when he was not painting Feininger played the harmonium. And so the fugue, with its question and answer, which appeared as a theme in *Fugue in red*, to the Bauhaus circle seemed like an allegory of creation, through the creative process by means of the pure use of elements.

As well as musical themes, Klee used constructive, or, as he preferred to call them, 'absolute' images; *Schwankendes Gleichgewicht* (*Unstable Equilibrium*), 1922, is an example of this. In his teaching Klee often emphasised that some forms which consist of signs, such as the arrow or the question mark, could have the same rights as other forms, whether imaginary or real. In this work he showed how the mental effort of 'making an unstable equilibrium visible' could be put into practice through formal elements. Art does not reproduce visible things, it becomes the metaphor of situations which arise from our vision of the world.

Klee called these images 'absolute' because he found the expression 'abstract' too inexact and arbitrary, and because he always wanted to keep his images open to reality. It was not far for Klee to go from these absolute images to paintings whose principle was the drawing of musical notes and their arrangement. *Kühlung in einem Garten der heissen Zone* (*Cold in a garden in the hot zone*), from 1924, almost looks like a page of a musical score, and its structure is a musical composition, made visible on the paper in its written copy.

During Klee's Weimar period, music was always a principle of composition to him, and also, next to architecture, a source of inspiration. Often architecture and music come together, for instance in a number of paintings dealing with performances of plays and operas. These images must be more numerous than we know, because Klee was a great theatre-goer and the transformation of a libretto into musical action could make him as en-

thusiastic as the transposition of a mental concept into a visual composition. For Klee, the theatre was an allegory of life. The drawing *Puppentheater* (*Puppet theatre*), 1923, was born from the little theatre he made at home for his son Felix. Here too, some elements, like the shape of the heart on a breast and the figure of the puppet, produce forms without sacrificing themselves. And the various colours against the blue-black background, the puppets' eyes standing out in that big black area, make the picture extraordinarily expressive. Also inspired by operas and performances, although in another sphere, is the fine drawing *Kampfszene aus der Komisch-phantastischen Opera 'Der Seefahrer'* (*Battle-scene from the comic fantastic opera 'The Seafarer'*) 1923.

Fig. 10

Here the hero, in a small boat, fighting three fantastic sea monsters, is shown against a background of blue-black squares; the full light of Klee's creative direction of this performance falls on the place where the hero's lance has stuck in a monster's mouth, from which two great drops of blood are falling. A drawing like this is an example of Klee's gentle, poetic humour, which, as Grohmann pointed out, was much like the poems of Christian Morgensterns in its unspoken allusions. At the same time the drawing is one of Klee's variations on the theme of the world, as a theatre.

Drawings of this kind are part of Klee's 'Inventions'. In the work of his Weimar period they often indicate the serene, light-hearted side of his nature. They recall the fact that he enjoyed Aristophanes and Hoffmann, and that he had found inspiration in *Candide* when he was a young man.

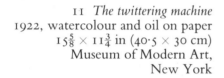

11 *The twittering machine*
1922, watercolour and oil on paper
$15\frac{5}{8} \times 11\frac{3}{4}$ in ($40 \cdot 5 \times 30$ cm)
Museum of Modern Art,
New York

The title 'Inventions' might well be given to these drawings, which are often of a purely graphic quality, because the invention of its themes and figures always starts from an idea of a technical or compositive kind: from elements that produce forms. This process shows itself most clearly in the fine drawing *Die Erfinderin des Nestes* (*The discoverer of the nest*), 1925, in which the use of small stripes as feathers may have given Klee the idea of associating the construction of the nest with the formal theme of the drawing. *Die Zwitschermaschine* (*The twittering machine*) and *Seiltänzer* (*The tight-rope walker*) are part of this series, which is born from the richness of the forms' elements.

Fig. 11

It should never be forgotten that Klee started from elements, that is, from compositive means, and then came to nature metaphorically, at the most. Grohmann mentions a good example of this in Klee's series of pictures of sand-dunes. The series did not start with the drawings that were closest to nature, but with a composition of coloured squares, among which plant signs were later placed, so that only then did the drawing become a landscape in which houses, sand-dunes, and plants were recognisable. Grohmann added that Klee had no need to look at nature; he studied it in his mind, as he used to say when he was teaching. In a lecture he gave at Jena in 1924, Klee mentioned his own thoughts on the theme of nature and artistic creation. They were a synthesis of the theories that had matured during his long period of teaching at Weimar and were expressed in his work. Some parts of this lecture therefore apply to works already mentioned.

An essential point in the lecture was the artist's relationship to nature. Klee considered the artist 'a being who, like nature, has been put into a multiform world without having asked to be, and who, willy nilly, must find his bearings in it'. 'He is distinguished from nature only in this: he gets himself out of the trouble through his own specific means.'

Klee explained this last sentence with an example. 'Let me use an allegory, the allegory of a tree. The artist has concerned himself with this multiform world, and let us admit that he has found his bearings to some extent, in silence. He has found his bearings so well that he can arrange the series of phenomena and experiences. I should like to compare the way in which the things in nature and in life, this whole branched order of things, are arranged, to the roots of a tree. From it the lymph flows up into the artist and passes through him and through his eyes. So he finds himself in the place of the tree trunk. Held there by the force of this flow, and moved by it, he transmits what he has seen through his work. His work develops visibly in all directions, in time and space, as the leaves of the tree do. No one ever suggested

12 *Castle to be built in a forest*
1926, watercolour
$10\frac{3}{8} \times 15\frac{1}{2}$ in (26·5 × 39·5 cm)
private collection,
Berlin

that a tree's leaves should be formed like its roots. Everyone knows that there cannot be an exact relationship between the bottom of a tree and the top. Obviously there must be notable differences between the elementary parts of it, because the functions of these parts are different. But people sometimes say that the artist should not differ from his model, although it is creatively necessary for him to do so. In fact, the artist in his creative ardour is sometimes accused of being impotent, and of consciously falsifying things. For this reason he merely collects and transmits what comes from above, in the place he has been assigned beside the tree trunk. He neither serves nor dominates – he transmits.

'So his position is a modest one. He himself is not the beauty of the leaves; that has merely passed through him.'

In this lecture Klee also described the way the artist worked. He tries, Klee said, 'to arrange the formal elements so purely and logically that each is of necessity in its place and none harms another'. At this point he may hear the layman object that the images were dissimilar. But the painter carries on, unruffled ('if he has steady nerves'). Klee continued with his explanation: 'But sooner or later, even without the layman's remark, he may see an association so perfect that nothing can stop him using it if it can be expressed in a suitable way. This may mean adding something that is related to the subject; objective attributes that are added to an element as if they had always been there, if the element still has a slight deficiency of form. All this happens if the artist is lucky. So one should be concerned not so much with the existence of the object as with its appearance, its species.'

As far as Klee's art was concerned, and in particular the work of his Weimar period, these associations with nature were important; his work was open to all the forms of nature, and reflected its richness and multiplicity, not confining itself to the harsh laws of *natura naturans*, which abstract art aims at with puritanical zeal and total exclusiveness. Yet Klee's objective was similar to that of the abstract artists. In his lecture he formulated it as being 'from model to prototype'; he sought the creative fount or archetype of all phenomena, or, as he called it, 'the secret fount, where the original law nourishes its development'. He explained the meaning of his work and the object of the new art in this way: 'Our beating heart pushes us down, down to the primitive depths. What is produced by this movement could, if you like, be called dream, or idea, or fantasy. We must do things seriously only when we want to unify all with the creative means suited to giving it a form. Then certain curious things become reality, the reality of art, which widens life more than seems possible. Because they do not reproduce what we see more or less with our senses, but make visible the things we watch in secret.' Klee's work started from these principles and he said the same thing in his teaching. Work and teaching were a unified whole and to Klee's pupils images must then have been a 'suggestion', a chance to find their bearings. He knew, and always sought to emphasise, that as far as visual art was concerned the meaning of the message was important, but not merely that. In his lectures he insisted on explaining very clearly his 'theory of creative forms' (1921–22). 'The story of the image starts even before the first mark is made, through the wish to express oneself, to be fully ready. But the most perfect will is no use without the necessary means to express it.'

In December, 1924, the Bauhaus had to stop working at Weimar. In the spring of 1925 it was transferred to Dessau and in December, 1926, Klee moved there, into one of the beautiful houses which Gropius had designed and built for the members of his teaching staff.

Kandinsky was a neighbour. Klee's daily work with his students was done in Gropius's new building, which was so light and functional that it seemed to reflect all the new ideas which had been developed at the Bauhaus. From its foundations in Weimar in 1919, the building as a model of functionalism had become less important. The 'cathedral of the future' belonged to the history of an institute that at the start had seemed, in many ways, a young movement. A new motto, formulated by Gropius and presented to the staff

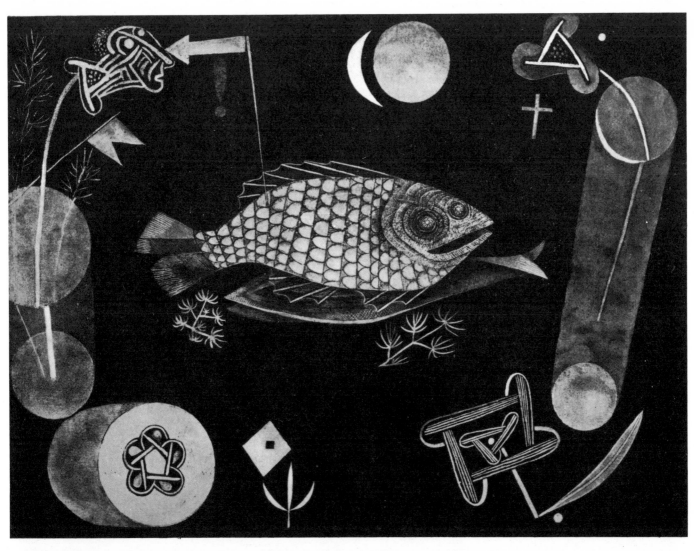

council, in particular by Moholy-Nagy, was: 'Art and technique, a new unity'. In this atmosphere Klee continued his wok at Dessau.

At Weimar he had seen the whole of his artistic activity at a glance; in his teaching and in his lecture at Jena he had pushed back the frontiers of reality as far as possible. After the years of discovery at Weimar, it appears that he now made these discoveries exact, and worked more intensely, more broadly. A vigour that suited the new ideas of the Bauhaus appeared in his work, expressing itself in a preference for clear straight lines and curves, above all in his drawings. *Schloss im Walde zu bauen* (*Castle to be built in the forest*), 1926, is a clear example of this style, which, as its title suggests, recalls technical drawings. *Gebirge im Winter* (*Mountain in winter*), 1925, has the same formal atmosphere, careful and clear. It is a drawing in which prismatic spatial forms are produced by a spray technique and acquire their clear, cold precision in an obvious way, merely through the contrast with an ethereal plant form which is set in the foreground with a sort of transfer technique. Works like these, which began with a composition of parallel lines, or through the contrast between a crystalline and a vegetal form, suggest the style Klee would be using in his years at Dessau. One cannot really call it a new phase, but rather a change of spiritual atmosphere, in which, instead of painting buildings rising towards the sky, and built by millions of human hands, Klee painted a technical product, precise and machine-built.

Colour, too, was important in this alteration in his style. During the Dessau period, colour and a vigorously articulated line were used far more clearly than they had been before. In his teaching at the time Klee spoke of

Fig. 12

15 *Highway and byeways*
1929, oil on canvas
$32\frac{3}{4} \times 26\frac{3}{8}$ in (83 × 67 cm)
Frau Werner Vowinckel collection,
Munich

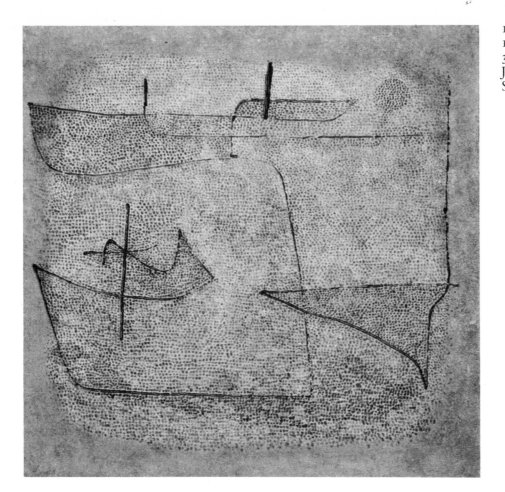

16 *At anchor*
1932, oil on canvas
34⅝ × 37 in (88 × 94 cm)
Joseph Pulitzer collection,
St Louis, USA

colour as 'the most irrational thing in painting', but he also wrote, in 1926:
'I have always sought it: tried to arouse certain sounds drowsing in me, an
adventure with colour, great or small.' Of course a clear division cannot be
made between the two periods, but even two similar paintings like *Goldfisch*
(*Goldfish*) of 1925 and *Um den Fisch* (*Around the fish*) of 1926 show the
difference in the concept of colour. In the one it is like a shrill sound, in the
other like a modulated sound. Geometry, which obviously has a greater
effect on the drawing and on the concept of form, seems to have over-
whelmed colour.

Fig. 13

But in the work of Klee's Dessau period, colour was still important as
something suggestive and metaphorical. This was not because the more
careful use of colour helped him to paint things more objectively. On the
contrary, it was because colour had freed itself more than ever from concrete
reality; it had become more accurate, and so better able to indicate spiritual
values. How much influence Kandinsky and his formal geometry had over
Klee as far as colour and form were concerned is something we can only
guess at.

However, there are many eloquent pictures, particularly from the years
1927 and 1928, that suggest Kandinsky's influence, particularly a series of
townscapes which often show the same clear and careful forms that Kandin-
sky was using at the same time–*Italienische Stadt* (*Italian city*), 1928, for
instance. In these, the town differs from those in the architectural water-
colours of Tunisia and the architectural paintings of the early twenties, in
which formal elements–squares, rectangles, and small triangles–become
roofs heaped up on top of one another. In the Dessau paintings the town is
not built from elements, but according to a plan that begins from geometrical
elements.

The beginning of these paintings may perhaps be found in some drawings
from 1927, in which Klee starts from the principle of the continuous line.
This flowing line, which bends only at right angles, is used in *Zweihügelstadt*
(*City on two hills*), 1927, and in *Auserwählte Stätte* (*Chosen place*), 1927, that

Fig. 14

is, in two architectural pictures. From these, it is a short step on the one hand to *Stadtperspektive* (*Prospect of a city*), 1928, a drawing which is very much like *Italian city* of the same year, and on the other, to a small painting called *Grenzen des Verstandes* (*Limit of the intellect*), in which the continuous line, as in an architectural drawing, forms the base on one side of which a kind of fire-escape rises uneasily into a cloudy starlight. Here, the building stands in an almost metaphysical atmosphere.

Another group of works is linked directly to this new theme: the designs and paintings whose subject is space. In these Klee was not interested in the illusion of perspective, but was seeking to suggest a feeling of space. Drawings like *Schwebendes* (*Hovering*), 1930, or *Verspannte Flächen* (*Surfaces in tension*), 1930, did not try to give an illusion of space, but, by the creation of a model, suggested a representation of spatiality. The use of the model, which distinguishes and determines Klee's work in the years at Dessau, is in full agreement with the past spirit of the Bauhaus.

The new sense of space, which became very important for Klee, particularly in 1930, might also have originated from the deep impression made upon him by a journey to Egypt in the winter of 1928–29. Space, in other words, must be understood in the context of Klee's many-sided vision. The dimension of space and the space of time, that is, history, influenced each other. Egypt was not merely the space of the Nile valley, but also the temporal prospect of five thousand years of a culture that was still visible. Out of this journey came a series of paintings in which Klee showed his greatest maturity and pictorial subtlety: works like *Monument im Fruchtland* (*Monument in a fertile country*), 1929, *Individualisierte Höhenmessung der Lagen* (*Individualised measurement of strata*), 1930, and, perhaps more persuasive, Fig. 15 *Hauptweg und Nebenwege* (*Highway and Byeways*), 1929. In all these paintings the drawing in stripes, sometimes in violent colours, sometimes in fresh, luminous tones, suggests wide spaces, an infinite extension in space. Klee thus defined his representation of space as the essence of the country, which satisfied his old longing for continuity, for slow growth and ripening.

At about the same time, around 1930, Klee had another spatial idea, that of 'divisionist' pictures. In these it was not the construction of lines, stripes and surfaces that formed the space, but light. Drops of different colours plunged the surface of the image in shimmering light, light arose from colour, movement Fig. 16 from light, and space from movement. The fine painting *Vor Anker* (*At anchor*), 1932, suggests a breadth, an infinity, that is exactly the opposite of built-up space; it is a space made of light, which spreads everywhere and has no limits.

Pl. 21 A 'divisionist' painting from the same year, *Ad Parnassum*, shows the splendid development and, once more, the weightiness of Klee's late work when it is compared with an early composition that has a similar theme – *Der Niesen*, 1915. Both paintings have, as a formal theme, the distant triangle of a mountain rising above the foreground. In the later painting, Klee's use of wider space produces a sense of dissociation through the use of coloured dots. The title, *Ad Parnassum*, of course suggests much greater dimensions in the second picture; but that is not all, nor is it confined to the painting alone.

In 1930, Klee made a drawing that was structurally close to *Surfaces in tension*, but in its meaning heralded a subsequent development: *Der Eroberer* (*The conqueror*). Here, for the first time, there appeared signs that Klee's gentle humour was to be overwhelmed by external events. At Düsseldorf he was coming up to his final years of freedom and maturity.

Berne, 1933-1936

Klee was one of the first artists to be dismissed from his work by the Nazis. In April 1933 he was told that he had been forbidden to teach; in December of the same year he moved to Berne, his home town, where he worked as a free artist. Ironically, it was as a result of the triumph of the oppressive Nazi regime that Klee moved out of Germany and became free of teaching, administrative work, and the many social duties his work at the Bauhaus

had involved him in during this period of his life.

He appreciated his new freedom. He was now more inclined to meditation, he re-examined the work of the past years and saw it in its totality. Thus he added to his earlier work, as Grohmann rightly observed.

These additions to his work of the Bauhaus period originated in a sort of revision which Klee undertook to fill the gaps in his past work, and from here he took up his own creative work with renewed vigour. It was characteristic of him, and of the situation in which he and many other artists found themselves, that the additions he made in no way reflected his mild, subtle sense of humour, in which his work from 1920 to the beginning of 1930 had been steeped. Indeed, humour vanished from his work some time before his illness, and before he had any presentiment of death. For a man of his sensitivity the Nazis' rise to power, Germany's lack of freedom and the oppression there, not merely in the arts, were reasons enough for him to lose his sense of humour, which had never been biting, but was friendly and restorative.

So that to works of his which had recalled Morgenstern's humour, such as *Erfinderin des Nestes* (*The discoverer of the nest*), *Die Zwitzschermaschine* (*The twittering machine*) or *Kampfszene aus der komisch-phantastischen Opera 'Der Seefahrer'* (*Battle-scene from the comic fantastic opera 'The Seafarer'*), he added only a few sketches in which the stylistic methods seem the same but the atmosphere is one of melancholy resignation. Among these were *W-geweihtes Kind* (*Child consecrated to suffering*), 1935, *Frühes Leid* (*Morning sadness*), 1938, and others like them. But even a drawing like *Clown*, 1929 is carried on and taken up in *Gelehrter* (*Scholar*), 1933, although here too the humour of the earlier work (which certainly had a tinge of melancholy about it) becomes silent resignation. Klee's humour, and with it one of his most charming and personal qualities, was lost when Hitler came to power and he went into exile (he was, and still remained, a German citizen). All this belongs not so much to Klee's biography as to the history of our time and the history of modern art. In 1933, a period of such bitterness began that there was no place in it for humour, even such a kindly sort as Klee's.

In all other fields, Klee perfected the work of his earlier years. To paintings with a strong linear structure, like *Schloss, im Walde zu bauen* (*Castle to be built in the forest*) he added the strange composition *Schöpfer* (*The creator*) in 1934, which gave the structure of the earlier work a metaphysical meaning. To designs for squares and structures he added *Überschach* (*Super-check*) in 1937. The series, which was built on continuous lines, was completed by the magnificent drawing *Wildwasser* (*Wild water*), in 1934, in which the moving lines suggest flowing elements as do Leonardo's sketches of whirlpools. And to the paintings with writing in them, such as *Pflanzenschriftbild* (*Vegetal ideogram*) of 1932, he added *Geheimschriftbild* (*Secret ideogram*) in 1934, which, for the first time, through a bold cross-hatching of lines, showed a later phase in his style.

Pl. 26

Besides these, there were paintings that belonged to a series with theatrical themes. *Figur des östlichen Theaters* (*Figure of the eastern theatre*), 1934, can be considered as a continuation of the theme of *Arab song* from 1932, although the theme was reduced entirely to associative signs, a pair of eyes, a veil, a heart. In a painting like *Grobgeschnittener Kopf* (*Head cut off by an axe*), in 1935, he returned, in his geometrical construction of planes, to sketches made around 1930, like *Surfaces in tension*. Only in a few paintings did he rediscover the lyrical, enchanted climate, quite beyond time, of the Tunisian watercolours. *Vollmond im Garten* (*Full moon in the garden*) of 1934, recalls an entry in Klee's diary in 1914: 'The evening is in me forever, profoundly. This pale rising moon urges me gently, like a soft reflected image, and always will continue to urge me. It will be my wife, my other self. It will urge me to find an incentive. But I myself am the rising of the southern moon.' The painting of 1934 was born from the spirit of those words; he had 're-thought' them.

The most significant work of Klee's years in Berne, during which he developed his earlier styles, is *Angst*, painted in 1934. This watercolour

belongs to the group of paintings of signs, or, as Grohmann called them in his catalogue, of paintings 'which are like symbols', such as *Feuerwind* (*Fire-wind*), 1922, and others of about the same time. In its rigid, formal structure, it is also similar to the 'divisionist' paintings from the last period at Dessau and Düsseldorf. What is new and typical of these later years, however, is the picture's emotional atmosphere. The symbols, such as the hands accompanied by arrows which emerge from the right, the oblique pupils like slits in the large round eyes, the way these forms draw away towards the left under the pressure of forces urging them on from the right, all these come from a world, and allude to a world, that had not been there since Klee's early etchings: the world of oppression. In his very early works, this suffering came out of his own emotions, whereas now it obviously came from contemporary events. This is a reason why all the terrible images of suffering in Klee's last creative period should not be connected with his own fate – his illness and his presentiment of death – but with the spiritual climate in which he lived. A painting as simple and as expressive as *Vogelscheuche* (*Scarecrow*) of 1935 belongs entirely to this world of obsessive visions, in spite of the subtle way in which Klee uses completely elementary symbols.

The great exhibition of Klee's work, which took place in February, 1935, at the Kunsthalle in Berne and was later transferred to Basle, shows an image of him quite unlike the one which appeared in the works he was painting at the same time. Anyone who, like the present writer, still remembers this exhibition, cannot avoid the feeling that Klee was showing just one aspect of his personality, and that it was wholly and substantially at variance with the spirit of the times. The works brought together at Berne and Basle in a splendid whole appeared to the visitor as a silent protest against the history of the age, against violence and terror. So remarkable a manifestation of 'committed' art would have been hard to find elsewhere, yet Klee had certainly not intended his work to appear so. On the contrary, he was and he remains the representative of an art that arose from a man's conversation with the world, from a man humbly listening to the voices of nature, which could penetrate his senses only through the greatest concentration. For this very reason Klee was wholly opposed to an age in which order and authority sought to mean everything, in which there was little room for the 'pure exercise of art' from which all his work began. In his lecture at Jena, he had said, resignedly: 'No people supports us.' In 1935, he could have said it again, with a certain pride in the face of a situation that had in no way changed. It was characteristic of him that he was silent, at least with words.

But in the summer of 1935 the illness from which he was never to recover and which slowly destroyed his strength appeared for the first time. For the rest of the year and for most of 1936 he had to give up work completely, although he improved slowly and in 1937 was able to paint again, although only by limiting or giving up every other activity.

After 1935, his work shows another style and attitude to life. No one will ever be able to say exactly how much his illness had to do with this change.

Grohmann, in his monograph, says that right up to the end Klee never gave up hope of being cured. But the world around him had also changed during his eighteen months of illness; in 1937, the year in which he began working again, the exhibition of degenerate art took place. It was also the year of Guernica – not merely Picasso's painting but the crimes of the German airmen in Franco's service, the prelude to so many future crimes. In the period between 1935 and 1937 the only complete break in Klee's work took place.

Final work, 1937-1940

Klee's final style was born from his illness. It was, above all, the expression of his altered vision of the world. Before we can understand the change entirely, we must consider the formal characteristics of his later work. These differed a great deal from those of his earlier periods, being determined by a feeling for the historical conditions in which he lived and which had influenced his own life. What are these characteristics, and what do they mean?

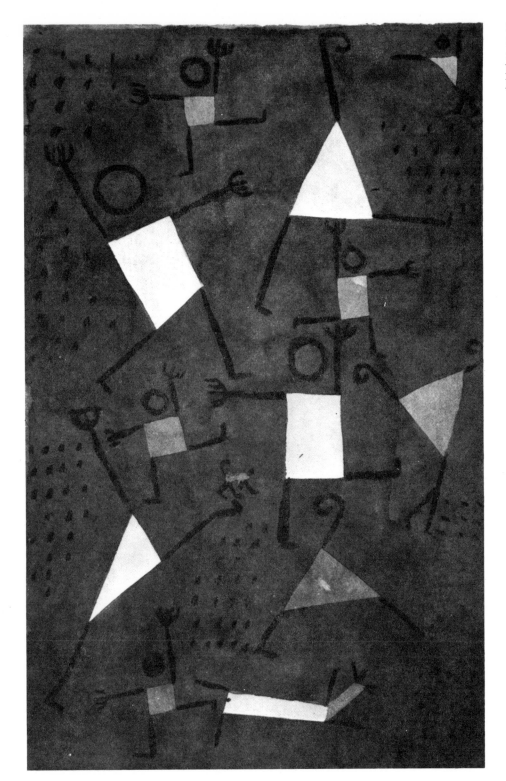

17 *They dance through fear*
1938, watercolour on canvas
$19\frac{1}{4} \times 12\frac{1}{4}$ in (49 × 31·5 cm)
Paul Klee–Stiftung, Kunstmuseum
Berne

The first difference between the drawings and paintings up to 1935 and those of the final period is their size. Until 1935 Klee worked above all on a small scale; Picasso spoke of his works, which he admired a great deal, as miniatures. *Ad Parnassum*, his monumental painting from 1932, was an exception, and he hardly ever used anything larger in size than a drawing pad. These small paintings and drawings depict the whole of creation, and are, in their own way, a 'little theatre of the world'.

Now his liking for small-scale work clearly changed. Most of his paintings after 1937 are sketched and finished on canvases that are as much as four or five feet in width or height, and are certainly the most important works of this period. The need to express himself on a larger scale must, in this phase of his style, have come from a deep necessity, a sort of severe interior warning.

His style also changed. The thin, delicate, hair-like lines which seemed to

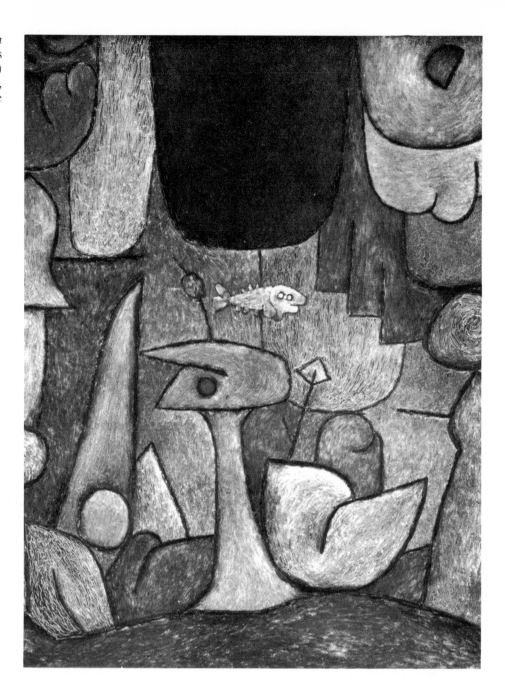

stop and linger now and then suggested a patient, careful choice. These lines now gave way to hard, powerful strokes which lay across the planes like beams across a ceiling. The lightness which had characterised Klee's drawing until 1935 gave way to a much sadder, more bitter style. Where the young diarist had written intimately and subtly, the ageing artist's writing seemed almost to do violence to his will.

Perhaps he found a connection with music here as well. A large work of this series is entitled *Heroische Bogenstriche* (*Heroic touches of the bow*), a musical idea that would hardly have been conceivable in his youth, except perhaps ironically. The surface is covered with lines, sometimes thick and sometimes thin, sometimes curved and sometimes straight; and in the spaces between them there are heavy dots and 'beams' that give the painting a rhythm at once heroic and sad. Remarkable, but also typical of Klee's way of working, is the fact that he painted another picture very similar to this, called *Der Graue und die Küste* (*Greyness and the shore*); the same compositional elements made him interpret the theme in a musical way in the one painting and through landscape in another.

This obvious change in his style was clearly the result of a change in Klee's spiritual outlook. What he had once said softly and hesitantly, or at least with an undertone of humour, he now proclaimed loudly and clearly, in a few well-chosen, violent words.

The process of creation in Klee was in no way changed, however. The example just mentioned, of two similar paintings with wholly different themes shows that, as he had done in his youth, Klee still started from a motif and then reached a particular, definite theme.

To Klee, the relationship between a picture's formal structure and its title was very important, and not only in this final phase of activity. As we know, he began from elements, from the use of form at its purest, and then let his associations wander and carry him along, often towards very different ends. This made the contents, the theme of a drawing or painting, quite precise, but in no way suggested a title. For this reason, Klee gave his painting a name, or christened it as he himself liked to put it, only weeks after it was finished. He would spread out on his studio table all the efforts and results of those weeks of work, decide if a work could be considered finished, and then begin to 'give names to his children'. He tried to translate the essence of his association into words, often very poetic words, and he was glad to hear other people's efforts at interpretation, and always listened to their views with interest. Sometimes he even changed a title after hearing them.

From this complex creative organism there emerged an important aspect of Klee's vision of painting, especially in his last phase, and that was the relationship between many images which seemed entirely independent. Klee's vision of the world was deeply rooted in the tradition of romanticism, which was born from a feeling for life that presupposed the original identity of nature and man, the identity of all creation, past and future. His contemporary, Rilke, who had the same feeling for life, spoke of 'the common base, the roots of which touch everything that develops'.

It was these depths that Klee touched, in his later works above all; he brought to light basic paintings that were the result of a disciplined use of

19 *Oriental sweetness*
1938, oil on canvas
$19\frac{3}{4} \times 26$ in (50 × 66 cm)
Jane Saversky collection,
New York

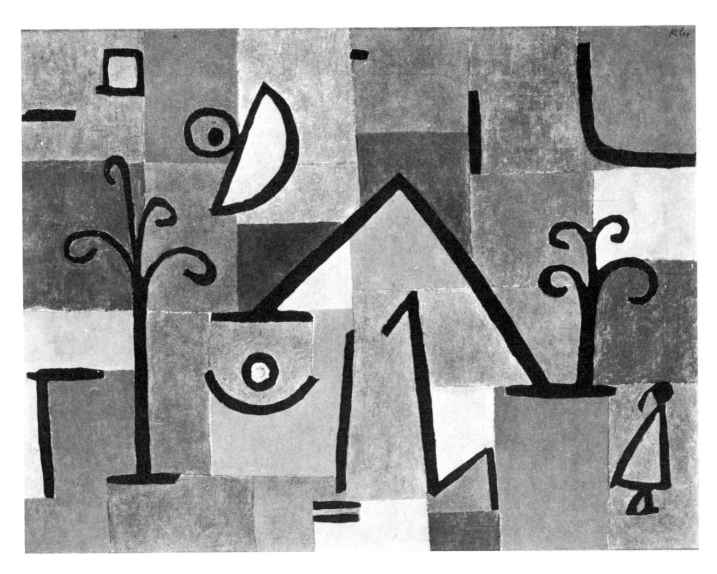

elements and their rich associations. And this gathering of tendencies and associations meant only that Klee often had contact with the subconscious. It was not the form of his paintings that he took from the subconscious, but the direction they were to take, after he had had what he called 'a concrete answer'. Later he created, transformed, varied and finally baptised them, making each one identifiable once and for all by giving it a precise image.

Klee must have realised, perhaps sometimes with fear, the abyss he revealed in his work – particularly in the final years. After 1938 demon figures became more frequent in his paintings, looming up from the depths, and the colour became dark, often muddy. Klee confirmed this earthbound (or even underworld) character in many of the titles he chose for his paintings: *Gäa, die alte Erdgöttin* (*Gea, the ancient earth goddess*), *Hades, der Gott der Unterwelt* (*Hades, god of the underworld*).

But the titles are only names for feelings or thoughts which the painting conjured up long before it was christened. How did Klee, when he was painting, achieve this sense of ghosts and underworlds, not just in the paintings with demon figures in them, but in those with harmless-looking subjects, still-lifes or landscapes?

20 *Park near L(ucerne)*
1938, oil on canvas
$39\frac{3}{8} \times 27\frac{1}{2}$ in (100 × 70 cm)
Paul Klee–Stiftung, Kunstmuseum, Berne

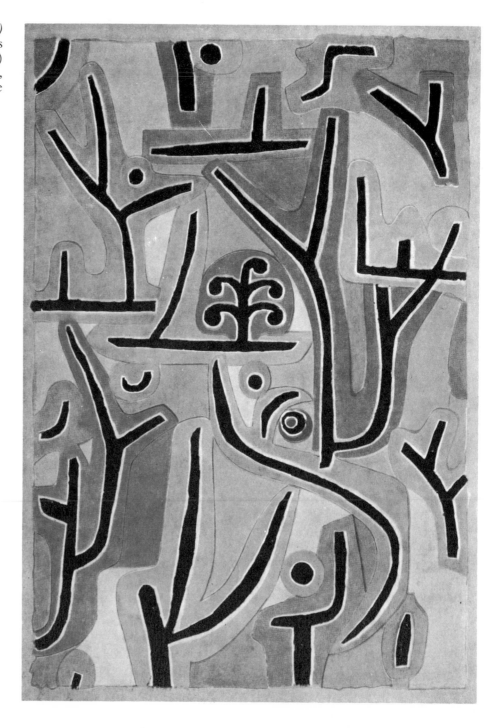

The feeling of tragedy and bitterness came, above all, from the heavy, clearly defined strokes. The difference in Klee's use of signs, and the form they took, is quite clear if we compare a limpid work like *Ein Blatt aus dem Städtebuch* (*A page from the book of towns*), from 1928, with a similar painting from 1940, *Schrift* (*Ideogram*). The fact that the earlier painting has a vertical shape, and the later one a long horizontal form that intensifies its air of tragic gloom, adds to the contrast. But another similar picture, from 1932, *Pflanzenschriftbild* (*Vegetal ideogram*), also has a horizontal shape, yet the lightness of its drawing prevents it from having any tragic associations. As always happens in Klee's work, the macabre nature of these paintings and drawings is derived from the equality and relationship of their pictorial elements; see, for instance, *Tänze vor Angst* (*They dance through fear*), of 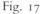 Fig. 17 1938, with its muddy background.

In the spaces left free, and lightly coloured by triangular or rectangular shapes, figures made of strokes and circles that suggest heads are dancing with movements that suggest something between ecstasy and exorcism. Their dance seems more like defence than joy, and the contrast between the violent gestures and the dark colour indicates clearly the meaning that Klee

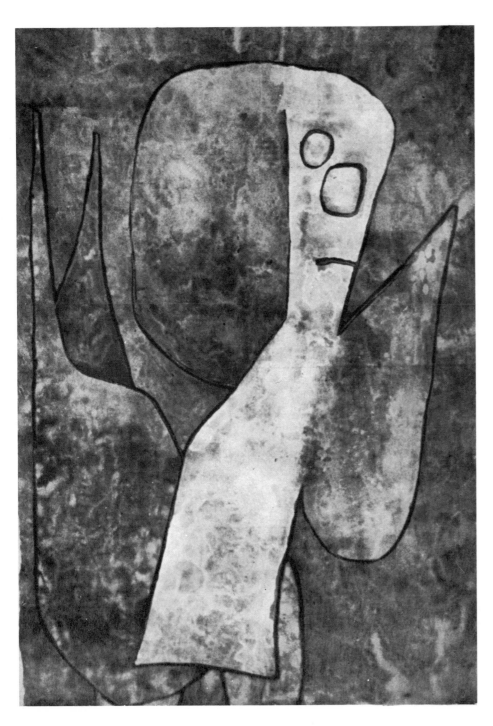

21 *Poor angel*
1939, watercolour and tempera on paper
$7\frac{1}{8} \times 12\frac{3}{4}$ in (18·5 × 32·5 cm)
private collection,
Berne

gave it in his imaginative title, *They dance through fear*.

But even other paintings, which might appear from their titles to be less sad, are imprinted with this sense of tragic seriousness. This is so even in a pastel that records Klee's happiest time, *Legende vom Nil* (*Legend of the Nile*), from 1937, in which it is the colour that particularly gives it its dark, tragic air – brown lines on a blue background in contrasting spaces. But a more careful look at the picture shows that it seems to suggest a scene taken from the *Book of the Dead*, and that a dead man is being carried across the river in a boat. This inspiration links a series of paintings which are so strongly suggestive that they might well be considered to be among Klee's finest and maturest works: *Liebeslied bei Neumond* (*Love song under a new moon*) and *Unterwassergarten* (*Underwater garden*), both from 1939, for instance. In *Underwater garden*, there are swimming fish, as in earlier paintings, goldfish for instance, but their situation is exactly the opposite of what it was before, just as, in Klee's later paintings, man's situation has also changed.

Pl. 37
Fig. 18

22 *Woman in national costume*
1940, tempera and flour glue on paper
$18\frac{7}{8} \times 12\frac{1}{4}$ in (48 × 31·5 cm)
Paul Klee–Stiftung, Kunstmuseum,
Berne

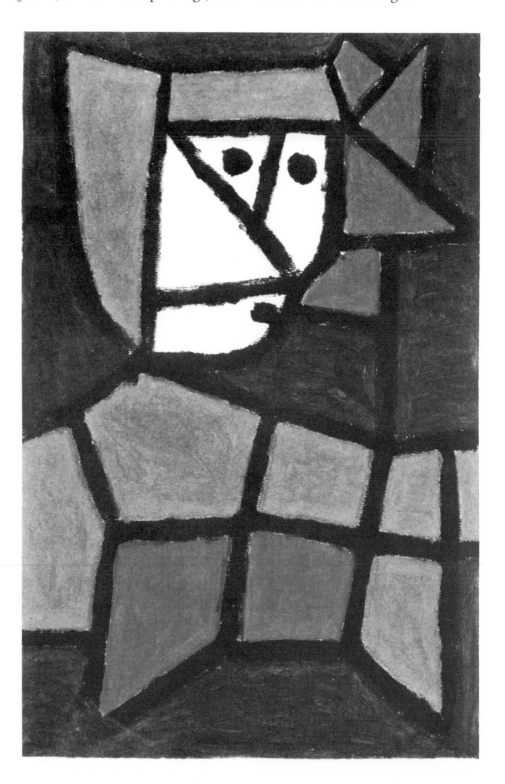

Not all the drawings and paintings of this late period can be called tragic, however, although so many of them are. Works like *Östlich Süss* (*Oriental sweetness*), *Vase* (*Vase*) and *Park bei L* (*Park near L*), all from 1938, in spite of their similarity to the tragic paintings of the same period, certainly radiate a happiness of their own. *Oriental sweetness* is perhaps the most perfect painting of this series and very clearly recalls *Legend of the Nile* from the previous year. In this, too, the background is divided into coloured sections with heavy black signs on them, and memories of Egypt are suggested by the hiero-glyphic of the pyramid and the palm, while the moon, a key element in Klee's post-Tunisian works, is linked to earlier times. There is a touch of melancholy in this recollection of the past but there is nothing tragic or ghostly about the painting. However, this and the other two paintings (*Vase* and *Park near L*) are entirely meaningful and valid examples of Klee's late style. What does it matter that they do not touch the depths of tragedy? Where, then, is the common denominator of the final works, if we refuse to

Fig. 19
Fig. 20

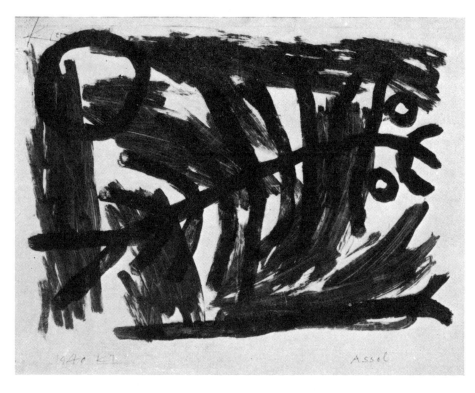

23 *Woodlouse*
1940, tempera and flour glue on paper
$11\frac{1}{2} \times 16\frac{1}{8}$ in (29 × 41·5 cm)
private collection,
Berne

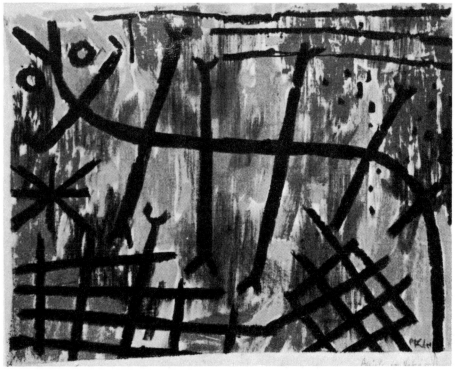

24 *Woodlouse in enclosure*
1940, pastel on paper
$12\frac{1}{4} \times 16\frac{1}{8}$ in (31·5 × 41 cm)
Paul Klee–Stiftung, Kunstmuseum,
Berne

accept the too easy explanation that Klee was dwelling on death and his long illness?

It is easier to answer this question if we compare the elements that are common to both the happy and the dark, sad paintings. In both groups the central theme is thick black signs on a coloured background, nearly always divided into sections.

In *Park near L* these signs, surrounded by a thin white border, form the structure of a number of zones of form and colour, on a background in various shades of blue. The signs in themselves and the background on which they are placed have a precise meaning, which arouses the association of the picture's theme, and then makes it echo.

This meaning is in fact the characteristic of Klee's final style: a soberness in the use of his pictorial methods, a tacit seriousness linked with the gravity of the time, are qualities common to the 'happy' paintings in their 'major' tone, and to the darker paintings in a 'minor' tone. It is this very sobriety, this concentration of the greatest possible force of expression in every mark, that distinguishes these works from those before 1937. Certainly Klee always used his pictorial methods soberly and conscientiously: he had no pictorial loquacity at all. But in the late works joy in communicating (which was often important in the earlier paintings) gave place to the expression of what was essential. Klee's final style is silent, and the values he expresses are eternal. It is the style not of an old man but of a wise one.

It was in 1939, about a year before he died, that the theme of illness and death became dominant in his work. He produced drawings and paintings which, although they continued to be in the style of the two previous years, with its sobriety and its intense concentration, can be interpreted only in one way, as far as their subject is concerned, and that is that they deal with man's

25 *Captive*
1940, oil on canvas
$18\frac{7}{8} \times 17\frac{1}{4}$ in (48 × 44 cm)
Frederick Zimmermann collection,
New York

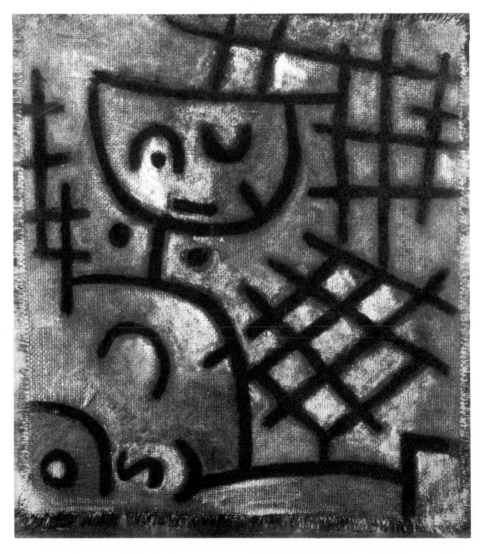

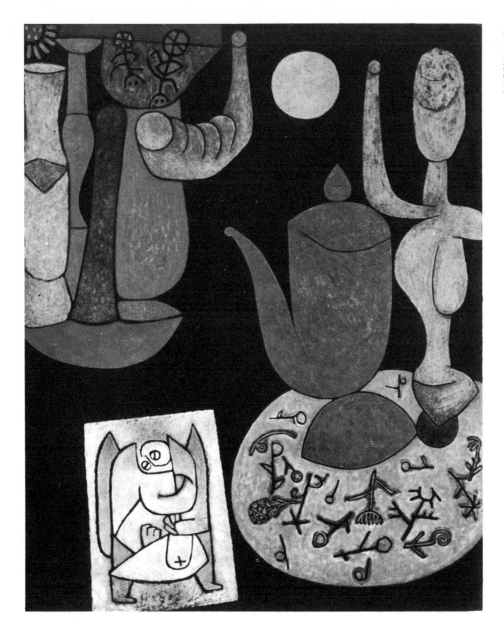

26 *Still-life*
1940, oil on canvas
$39\frac{3}{8} \times 31\frac{1}{2}$ in (100 × 80 cm)
Felix Klee collection,
Berne

relationship with death and his passage to another life, which cannot be envisaged. Charon, the boatman of the dead in ancient mythology, appears as the symbol of this passage. Grohmann rightly said that Klee drew his own requiem in the months before his death.

The series of angels is the beginning of this requiem. Klee had often chosen the theme of angels in his earlier work, but in 1939 there were more drawings of this kind and they referred quite clearly to death and the next world. It is certainly not possible to explain these drawings in relation to Klee's human destiny, so we must be content with guesswork, and suppose that angels gave him the only pictorial means by which a superhuman world could be concretely envisaged, and in which he was therefore in a position to make 'visible' a reality he foresaw and accepted. These angels appear in his work in the most varied ways, and with various titles. *Armer Engel* (*Poor angel*), a Fig. 21 painting from 1939, perhaps reflects the most moving aspect of this image and is very similar, both technically and thematically, to a painting from the same year and with the same tragic content: *Ernste Miene* (*Serious face*), in which the pale image of a head, showing empty eye sockets, emphasises the painting's expressive meaning.

In a number of works of this time there are many figures, besides angels, whose dark outline determines the character of the painting. Indeed these heavy outlines actually recall stained glass, and the coloured parts, which seem to lie between lines of lead, give the impression of light filtering darkly through the colour. *Frau in Tracht* (*Woman in national costume*), from 1940, Fig. 22

43

one of the strongest paintings of Klee's last months, belongs to this series. The figure can scarcely be identified as coming from the everyday world; it already belongs to the sphere of the angels.

Works characterised by heavy, cross-hatching also belong to this period. One of them, painted on heavy sacking, is aptly described by its title: Fig. 25 *Gefangen (Prisoner)*, 1940. The painting shows the head of a man and a few scribbles on his body, behind a grating of thick black bars which entirely deprive the figure of space. A similar theme, similar especially because of its Figs. 23, 24 pictorial treatment, is found in the series of the *Asseln. Assel im Gehege (Woodlouse in enclosure)*, also from 1940, shows a kind of centipede, like a hieroglyph, made of black stripes in a closed area surrounded by bars. The animal is trying to find a way out but is shut into the space – even the leaf is too small to allow it to stretch out completely.

These works can no longer be interpreted ambiguously, and they were Pl. 40 followed by others showing Klee's idea of his own death: for instance, *Tod und Feuer (Death and the fire)*. This is a problematical painting, because the subject itself is explained through signs and the title, but the meaning of the drawing is inexplicable. The pale head of Death appears on a red background, which towards the top becomes brighter. Death wears a green gown and in his right hand carries a yellow ball like a king's orb, held high. From above, on the right, a figure approaches, made up of a few strong black strokes, and above the head are another three black vertical strokes. That is all, and the painting's mystery is unsolved.

Fig. 26 Klee's last work was a still-life in which he seems to have given up alluding to his personal tragedy and fate. The painting has a black background, on the right is a table with a jug and a statue on it, and on the left are three vases of various colours. Almost in the centre, high up, is the disc of the moon, yellow as egg yolk, and at the bottom near the table a white page with an angel drawn on it (with the usual thick outline of recent times) tightly clasped by two hands. Is it Jacob wrestling with the angel? The picture is certainly masterly in its choice of colours and its drawing. What does it mean to the person looking at it? On Klee's tomb are his own words: 'In this world I am not understood. So I am better with the dead or with those unborn. Closer than usual to the centre of creation. But yet not close enough.' We cannot know the final truth; to know it we would have to mature like Klee.

The significance of Klee's work

After Klee's death, it was realised that all his work, in its complex totality, must be kept together. There was a great deal of it. Apart from paintings and coloured sheets, there was a large number of drawings which Klee had used as preliminary sketches for his work. There were also a great many sketches he had used in his lessons and in the small amount of writing he had published. When the Second World War was over, Klee's friends set up a foundation (the Klee-Stiftung) for this large body of work, in order to avoid the danger of its being seized as the property of a German citizen, for in spite of his efforts to obtain Swiss nationality, Klee had remained a German until his death. In 1953 his son Felix became president of the foundation after the retirement of the collector Rupf, and gave it a great many works, in particular about a thousand drawings.

Meantime, Klee's work had become known throughout the world. Soon after his death in 1940 a large commemorative exhibition was put on in Berne and New York, and in 1941 it was transferred to Basle and Zurich. But the chance of giving a complete, general idea of his profound and varied work came only when the Klee-Stiftung put on an exhibition with the loan of Klee's own works. These exhibitions started in 1947, in Berne, then were held in Paris, Brussels and Amsterdam, in Zurich and Basle in 1948 and in seven American cities in 1949. On the tenth anniversary of Klee's death in 1950, the Kunstmuseum in Basle showed a number of his works from private Swiss collections and in 1953 the Klee-Stiftung became part of the Kunstmuseum in Berne, and there nearly all the works of the foundation are shown. Once Klee's work was available for study, his fame, and the sense of

his importance, increased. And so Klee became one of the fathers of modern art. In his years at the Bauhaus Walter Gropius called Klee 'the last moral idea of the Bauhaus'. He is now among the great masters of his own age and of ours.

Klee was not an artist who chose a clearly defined way, as other great artists of his generation, such as Mondrian, did; nor was he like Picasso, an artist who, in the final analysis, is important for his authenticity and originality and can therefore change his style and themes many times. He was a mediator between different worlds, and his work achieves its deepest meaning through a synthesis which, to him, was more important than anything else. At the very beginning of his activity as a painter, in 1911, he said in his diary that an artist must be 'poet, naturalist, philosopher'. Probably he also felt that he needed to be a musician, but this was something so natural to him that he forgot to mention it.

In his work, a very fine web links music, poetry, natural science, philosophy, and painting. And this web, which has a visible structure, is, in Klee's own words, the 'analogy of the creation'. Klee's works are not analogies of the creation as individual paintings, but only in their formation and genesis. The way in which he allowed his paintings to mature, the way in which he always tried to keep a balance in their development, has something in it that is like the creation of the universe, which has come to seem like the human creative process. For Klee, balance was one of the most important elements in expression; he felt this about music as well, and in his lessons often used the example of the tightrope walker (and he also drew him): 'I swayed to the left and held myself up with the right hand, to avoid falling.' This was, basically, the metaphor of the dialectical process which is at the basis of all creation. The title *Das bildnerische Denken* (*Figurative thinking*), given to Klee's writings as a teacher, collected and published by Jürg Spiller, is exactly right, for it deals with the ways towards things, or the large number of these ways.

Klee wrote in his *Prinzipielle Ordnung* (*Fundamental orders*), which was based on his teaching between 1923 and 1934: 'Avoid all monotonous ways.' When work and method are as one, the work speaks for itself, and as it does so achieves its own variety. The various sections arrange themselves in a well-ordered whole.' It is this variety, instead of monotony, that characterises Klee's work and his method of working.

This polyphony in his work, which is yet another musical concept, comes from the way in which he made the many fragments of our world into a single, multiform whole. He not only united the disciplines he mentioned in his diary in 1911—art, poetry, the study of nature and philosophy—but went beyond them in time and space, harmonising Greek mythology with life today and bridging the gap between Egyptian culture and modern times. It was not mere chance that the revelation of painting came to him in Tunisia, in the eastern world of Islam for which he felt such understanding and sympathy. Perhaps this world was so close to him because it looks at forms, not as things, but as signs. Klee also found a way of uniting this world to ours, and included it in his *Summa,* where everything clear, limpid and pure has its place.

In his painting, Klee used the sign with the greatest possible accuracy, to turn the reality of the world into symbols that were always new, and added to it his musical experience. The clarity of his lines was like the purity of a violin's tone. Klee himself made this comparison: 'There is room for a profound study of art, and this has been needed for a long time. What happened in music at the end of the nineteenth century is only just beginning in the field of the figurative arts. Mathematics and physics give us the tools in the form of rules for norms and exceptions. It is a good idea to deal first with the function rather than with the perfect form . . . We learn to see behind what is obvious, and to consider things from their roots.'

This is, above all, what Klee's work, in all its profound significance, gave our time. It does not really matter whether he did it in his early works, like a

magician or a conjuror, or in his later works, through his aesthetic renunciation. However he did it, he managed to change the world; not merely to catch various aspects of human life, but to reproduce the time and space in which this change took place.

For the place in which Klee's paintings were produced and took their form is the kingdom of pure art, and lies beyond our concept of time and space. He worked and created in the kingdom of the subconscious, listened to the associations that lay about him, and then caught one of their voices in its rhythmic flight: 'All art is a memory of our dark origins, whose fragments live in the artist forever.'

So Klee 'melts into all', 'does not belong to our world and cannot be wholly understood' and is 'a point of cosmic, not spatial, reference', as he said of himself. This in no way means that he renounced his own personality. All that vanished into his work as the years went by was any reference to his own self; for he grew to realise, more and more, that he was part of a more important order of things, of which we can learn only a part, and of which we can perceive only a small fraction with our senses.

Thanks to the strict accuracy of his 'pure art', Klee managed to make some of this order visible. The demand he expressed in 1917 – 'the formal must melt into the ideal' – was constantly met in his own work. He will become part of the history of art as one of the great masters of twentieth-century painting, but posterity will probably consider him not so much a great painter as an innovator in the imagery of our world, in which things are not reality, but 'examples'. 'Art is an allegory of creation. It is always an example, as the mortal is a cosmic example . . .'

Today, the importance of his work is acknowledged by the young. Klee lives on, not merely as an artist, but as a master of humanity.

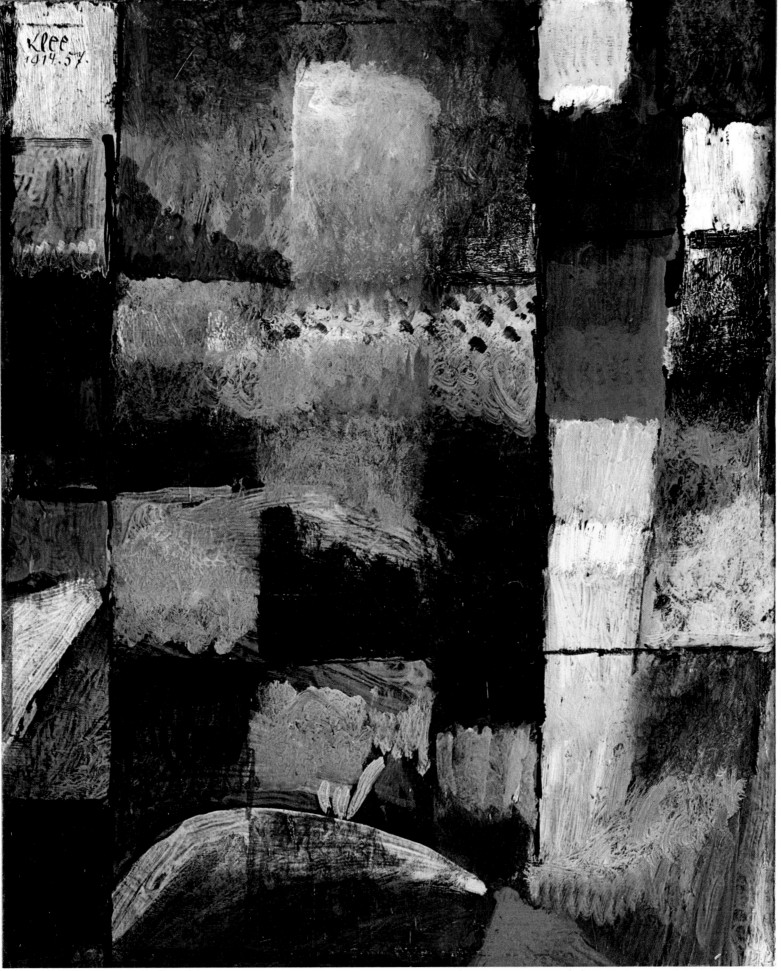

1

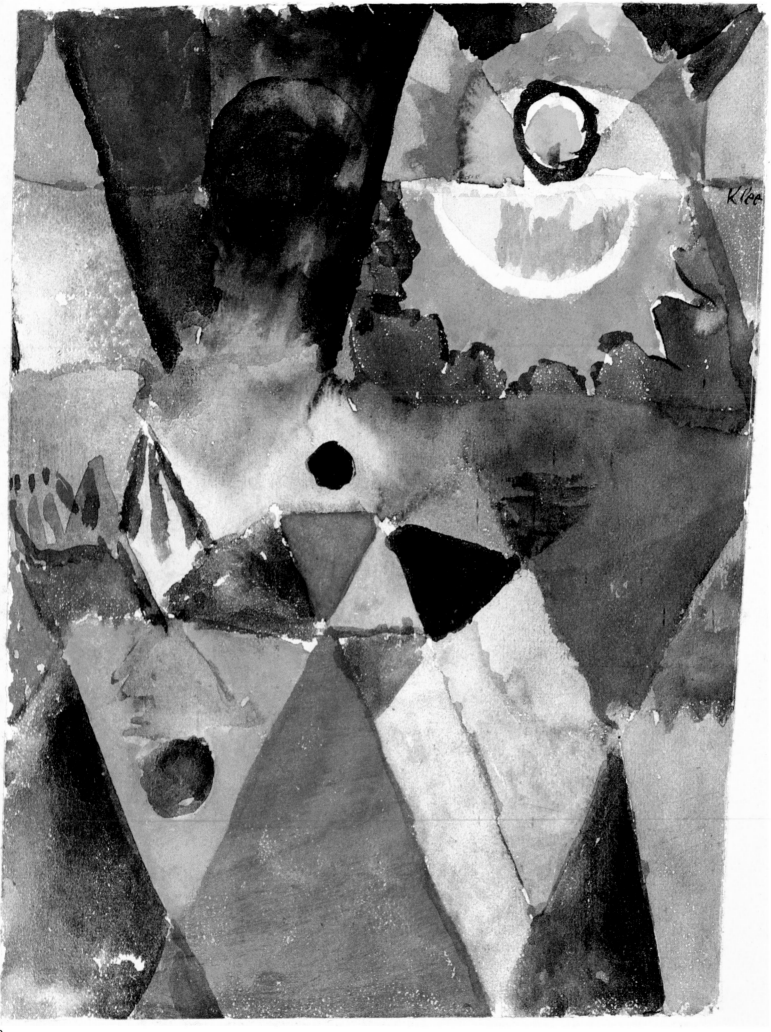

2

Einst dem Grau der Nacht ent taucht / Dann schwer und teuer / und stark vom Feuer /
Abends voll von Gott und gebeugt / Nun ätherlings vom Blau umschauert, / entschwebt
über Firnen, zu klugen Gestirnen.

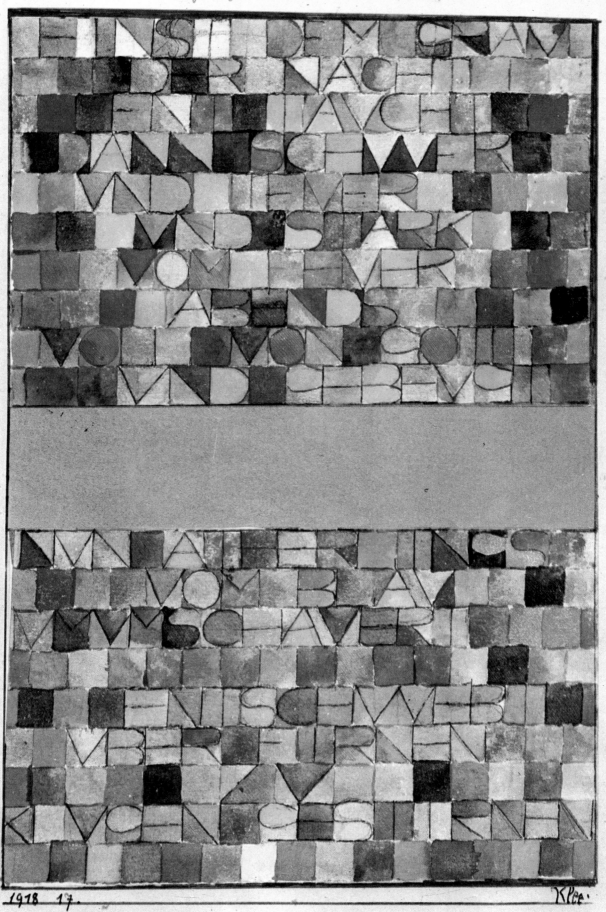

1918 17. Klee.

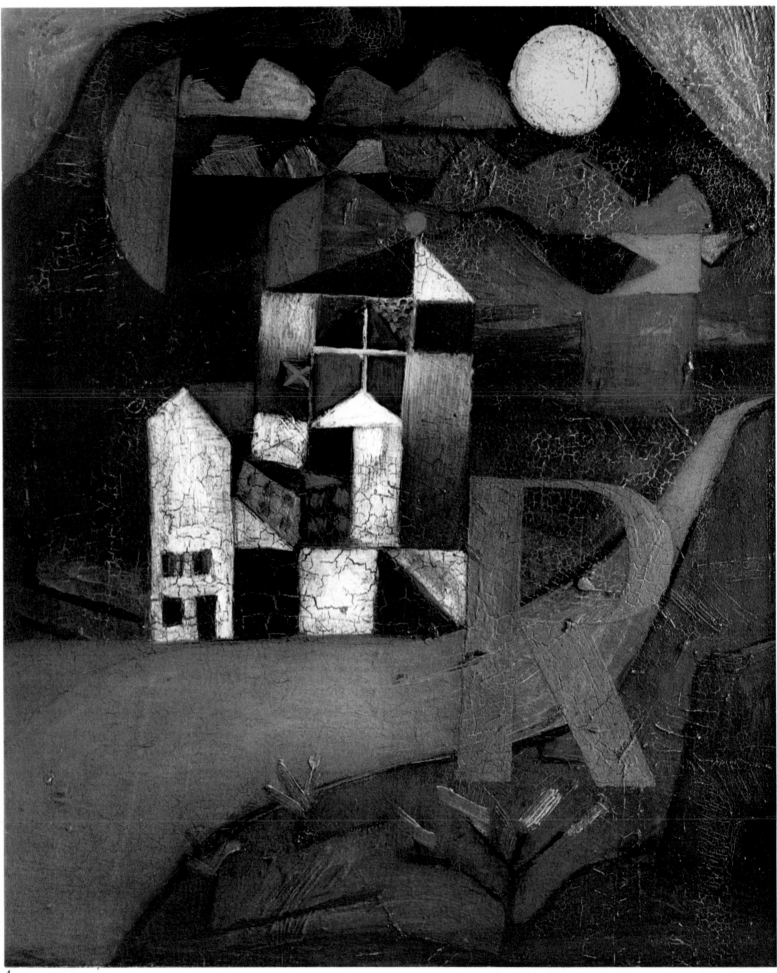

4

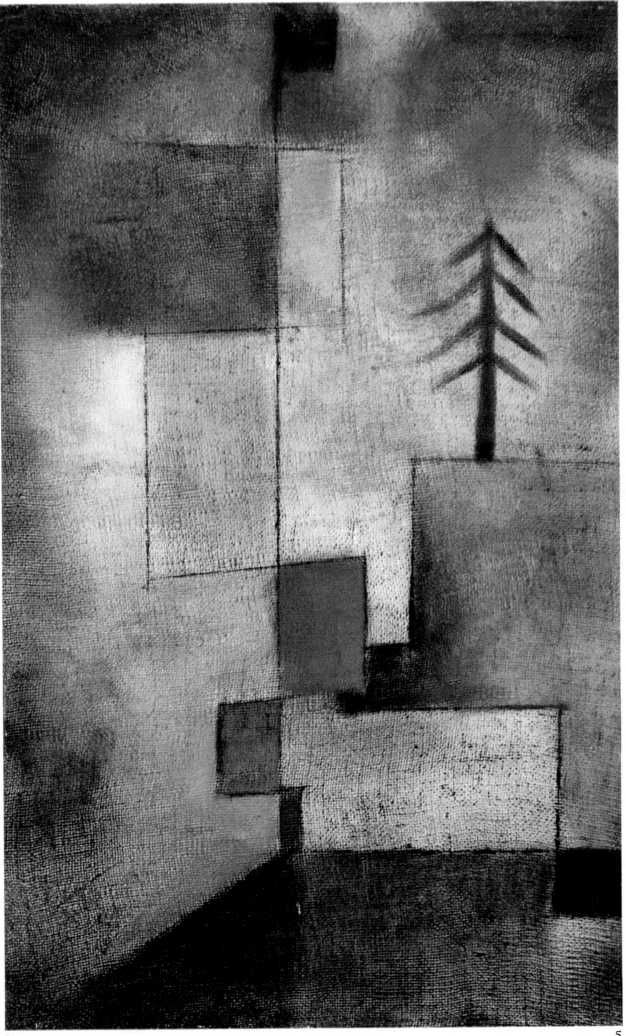

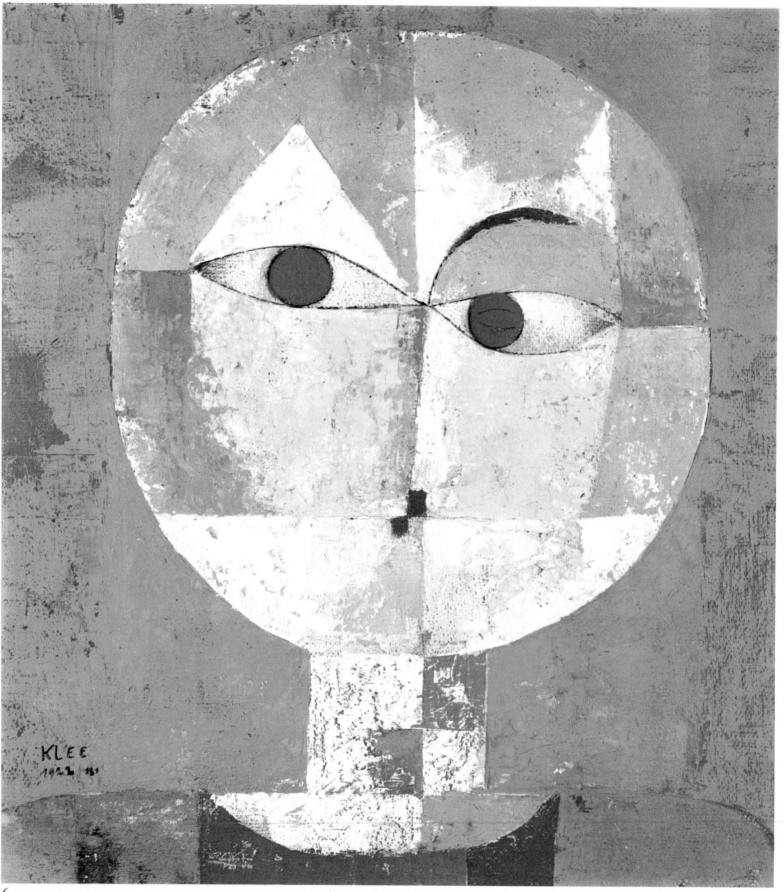

6

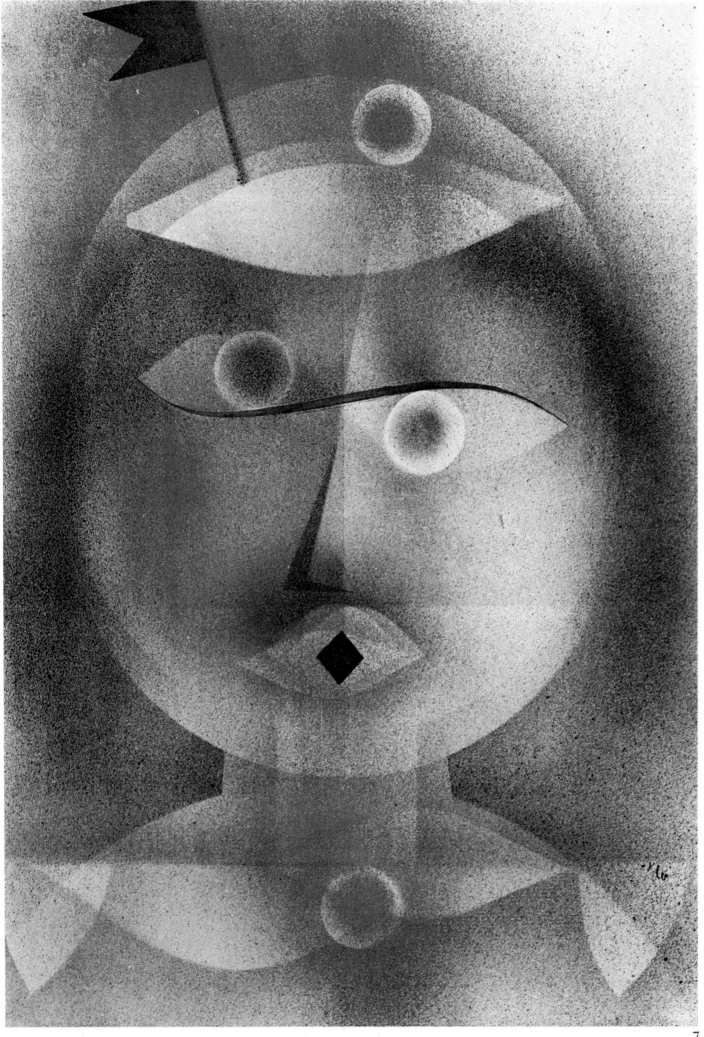

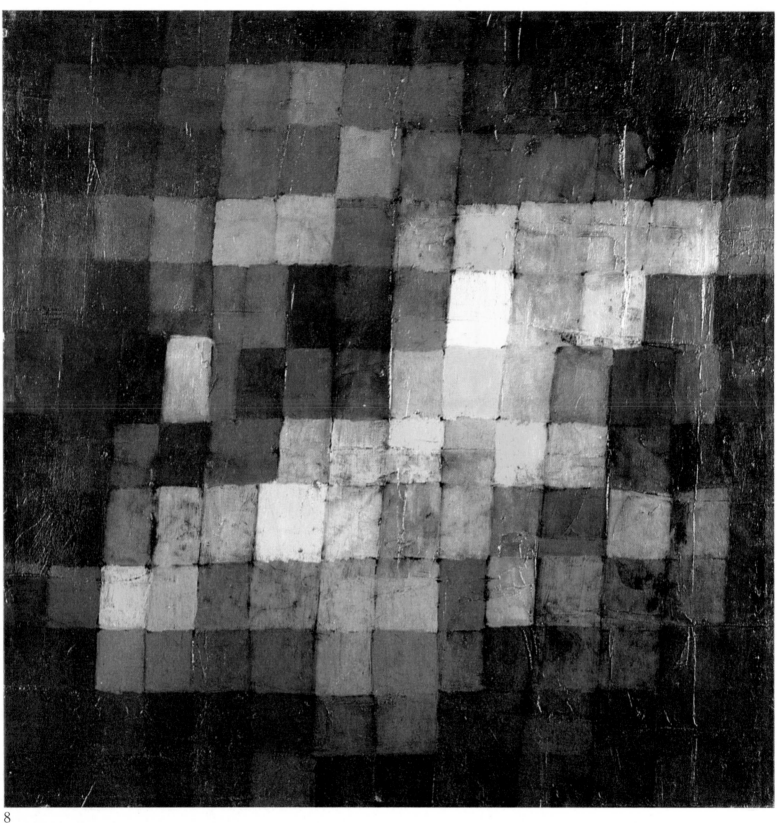

8

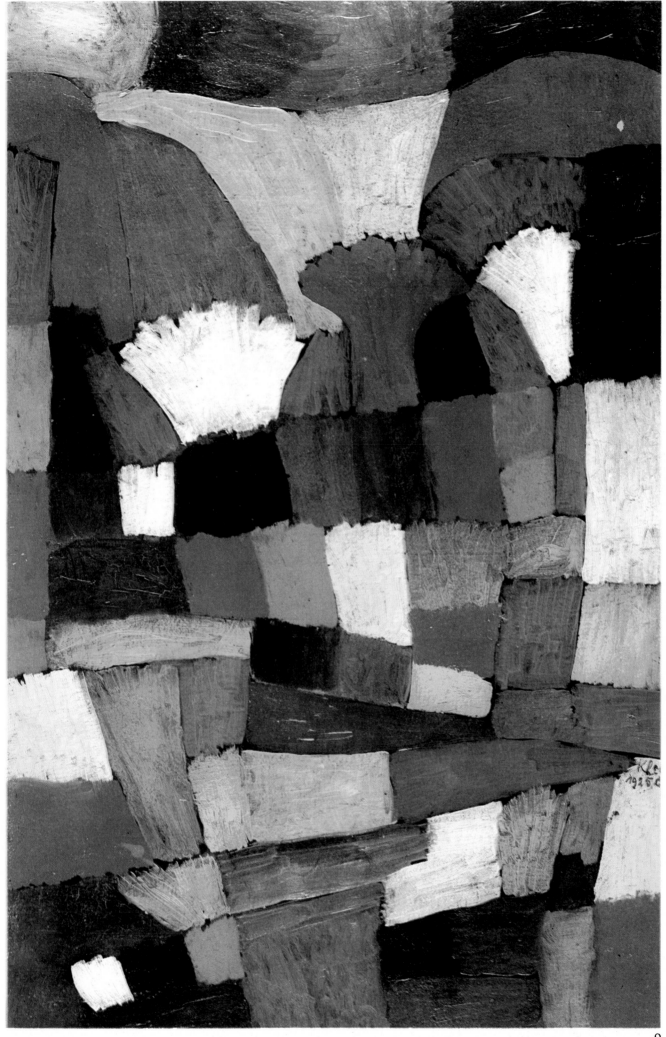

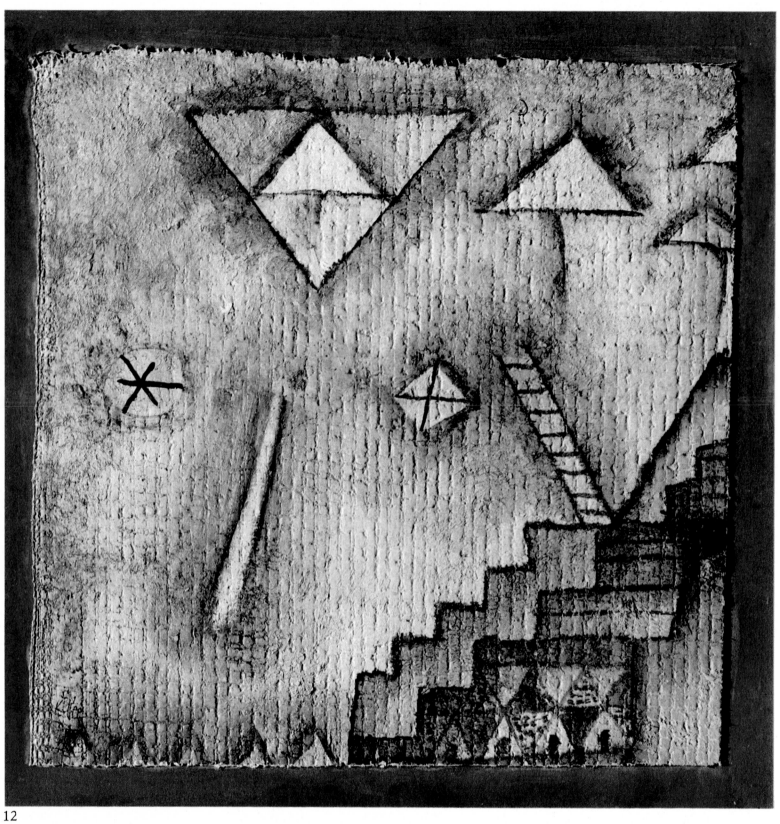

12

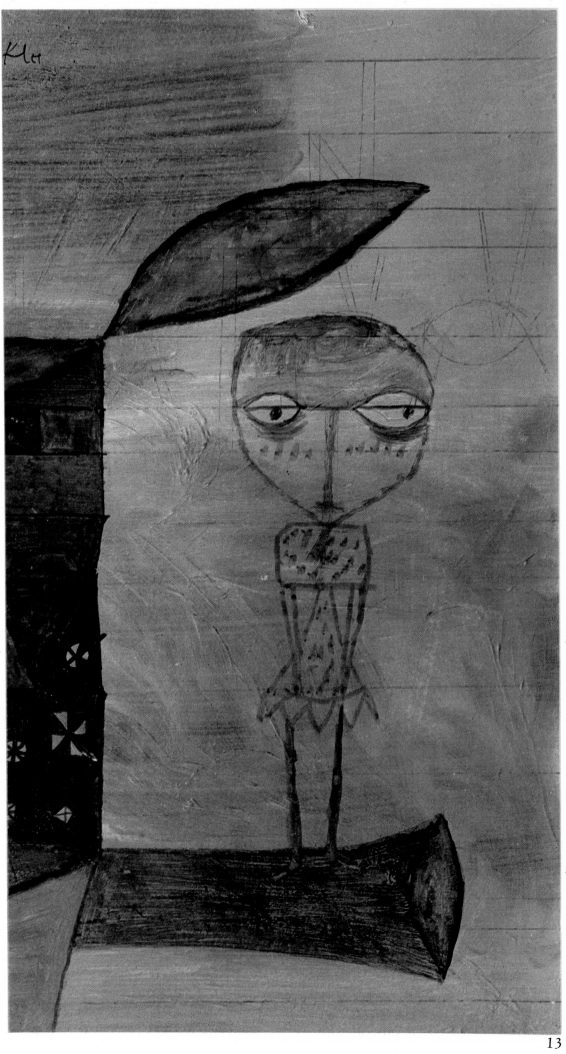

13

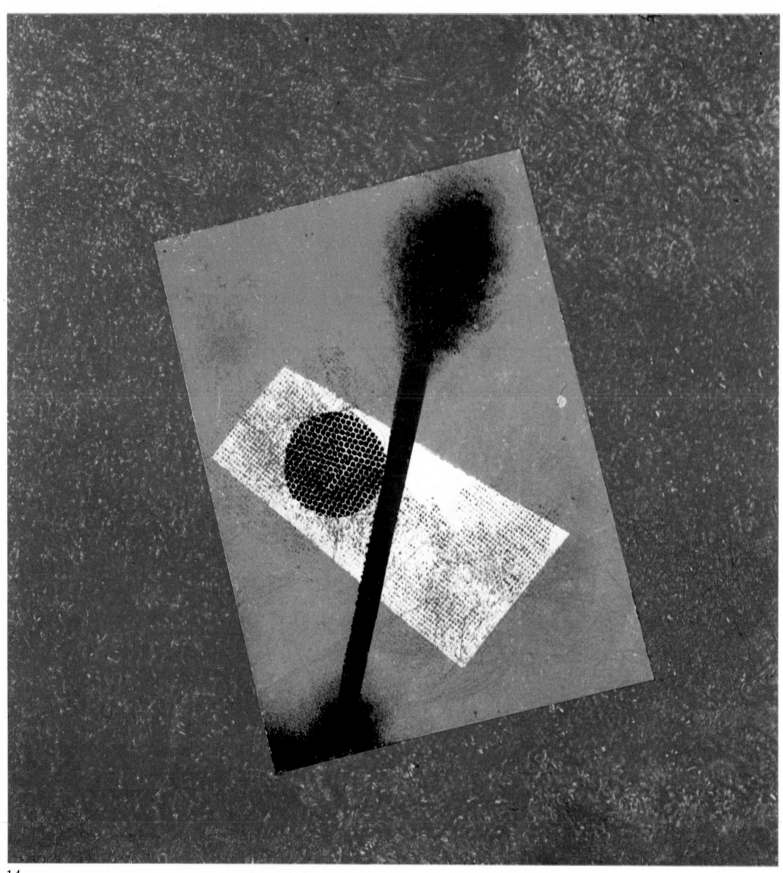

14

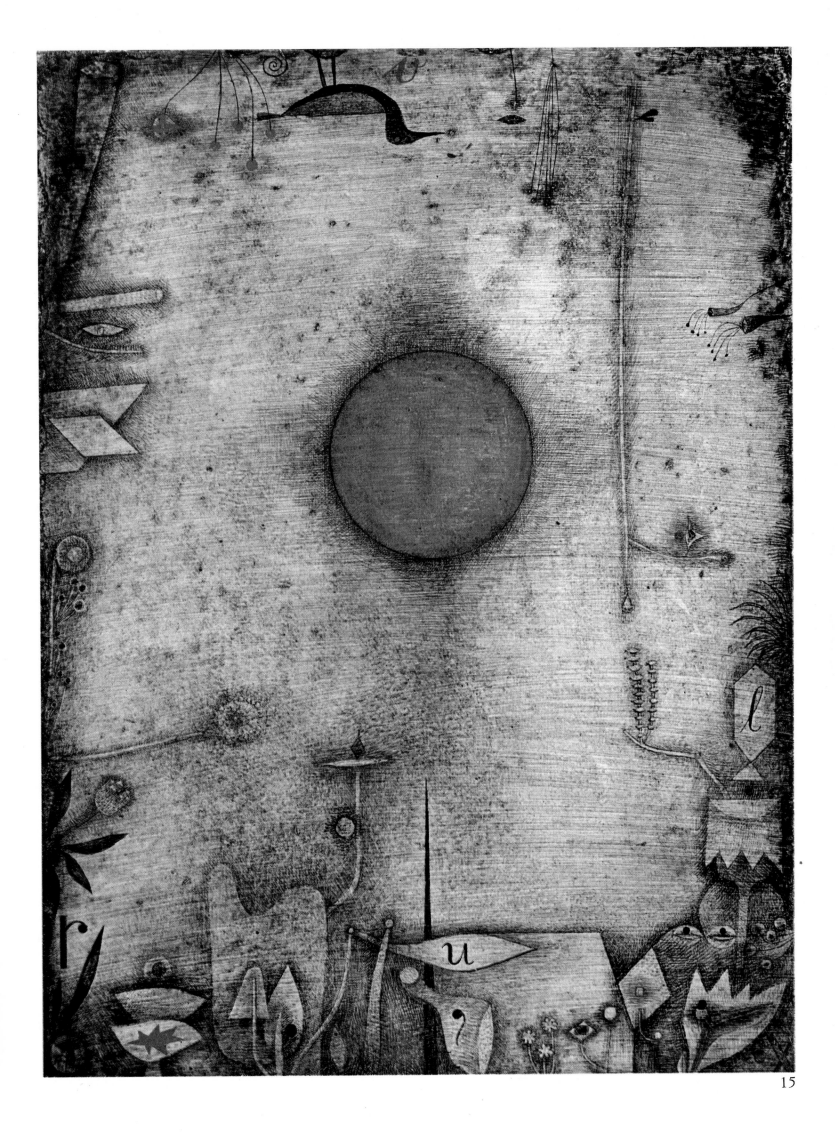

15

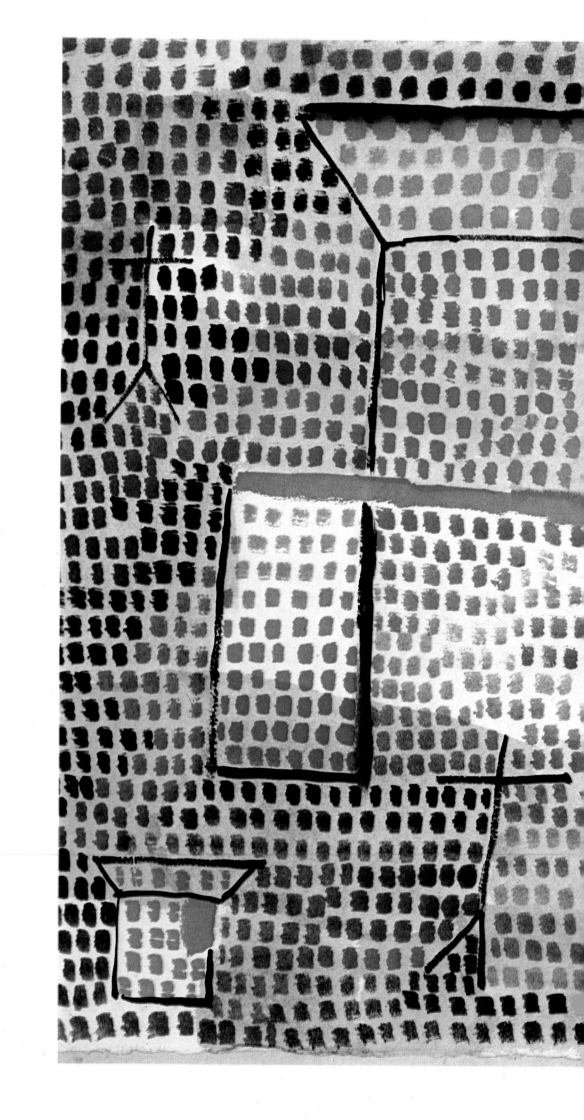

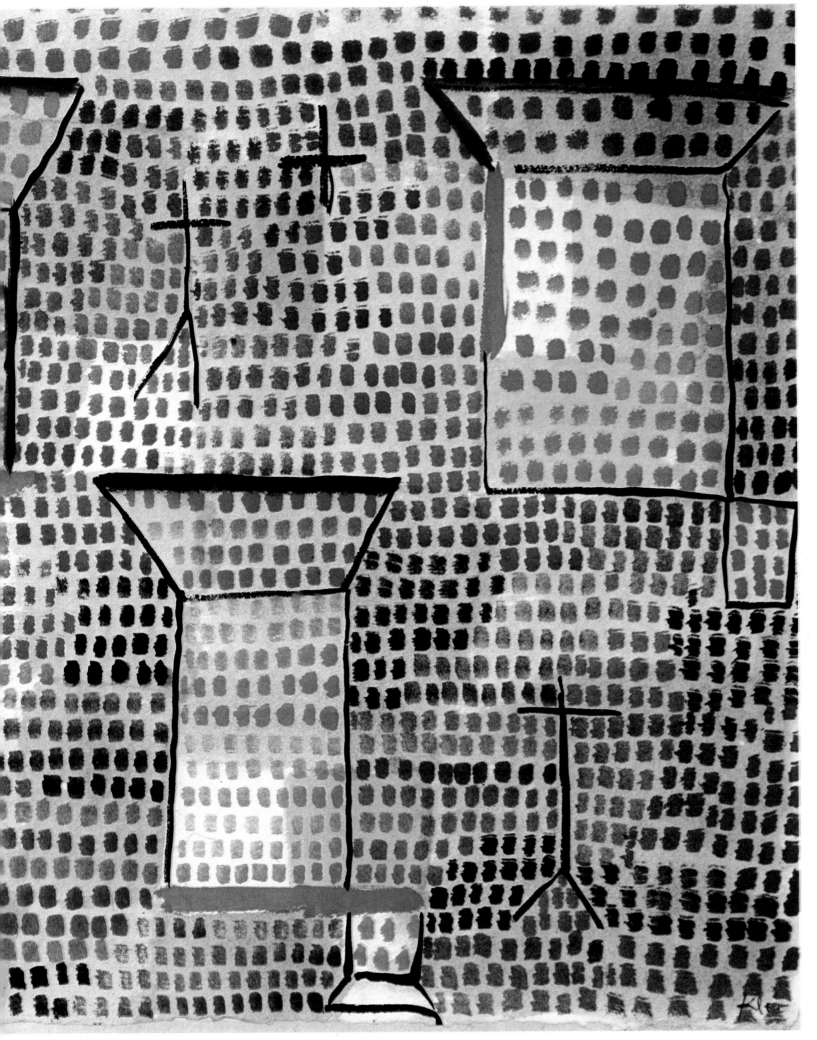

16-17

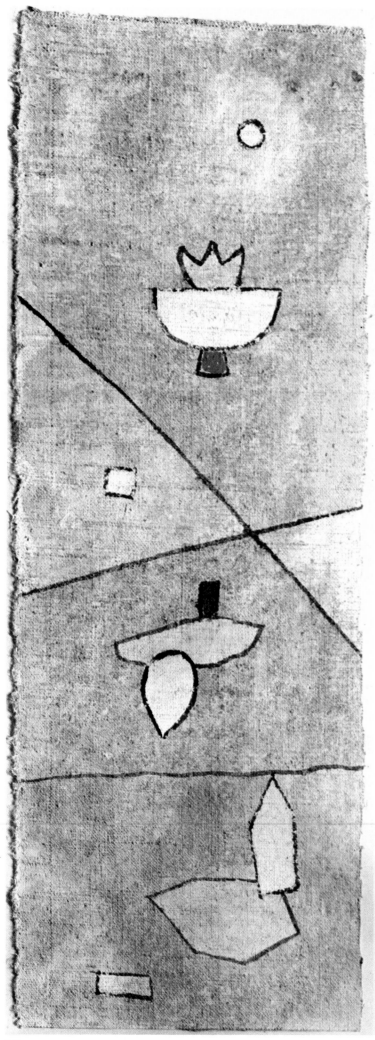

18

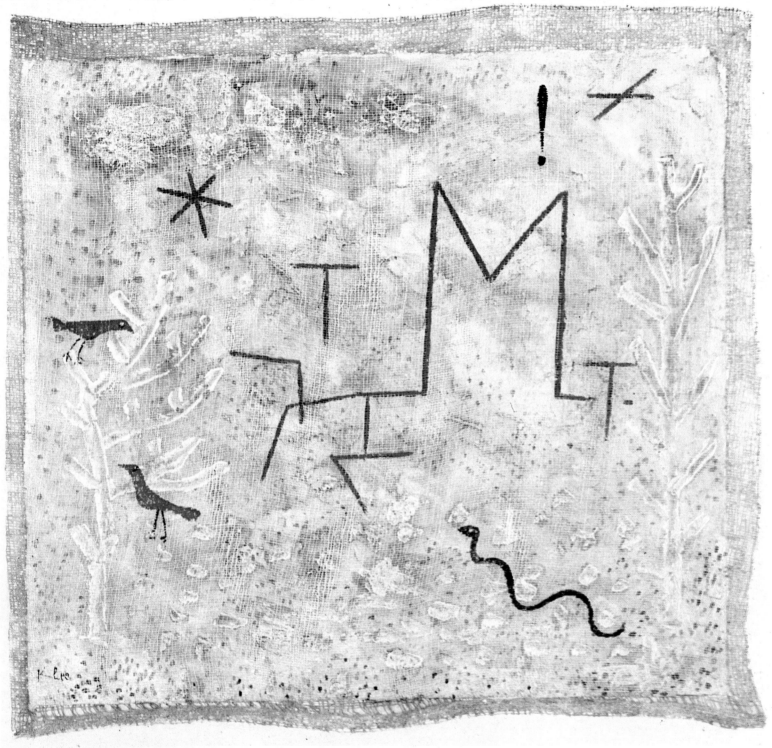

19

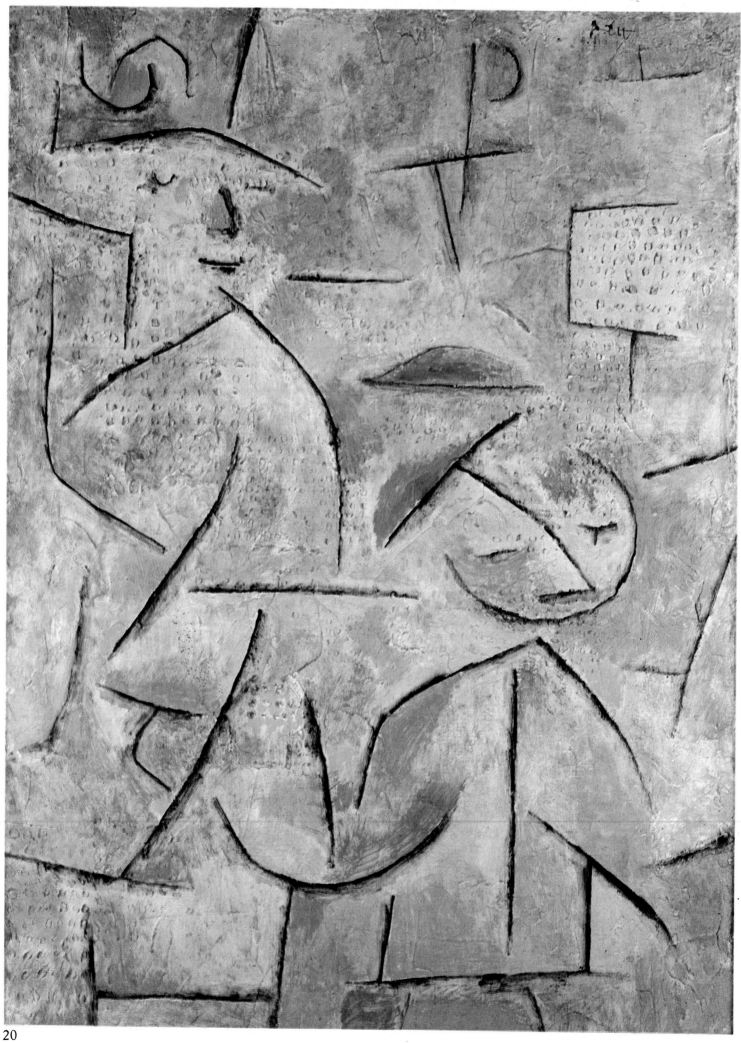

20

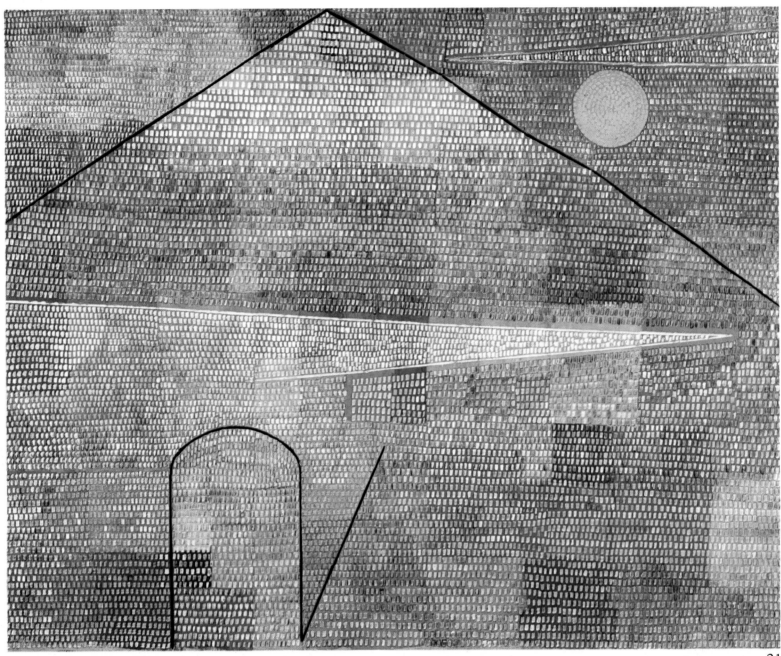

21

22-23

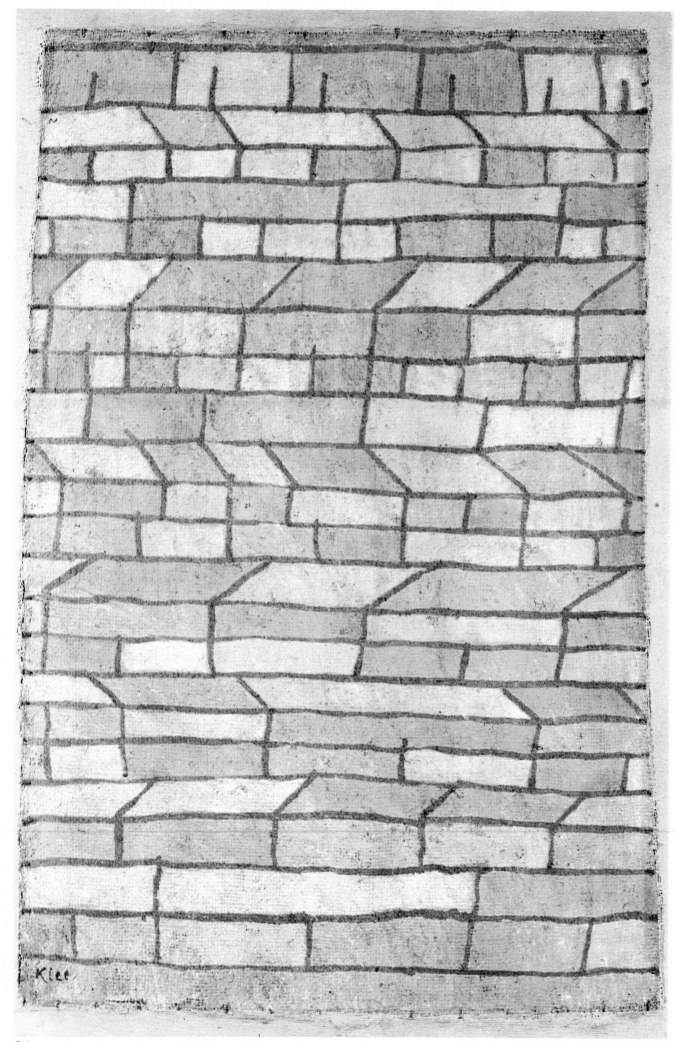

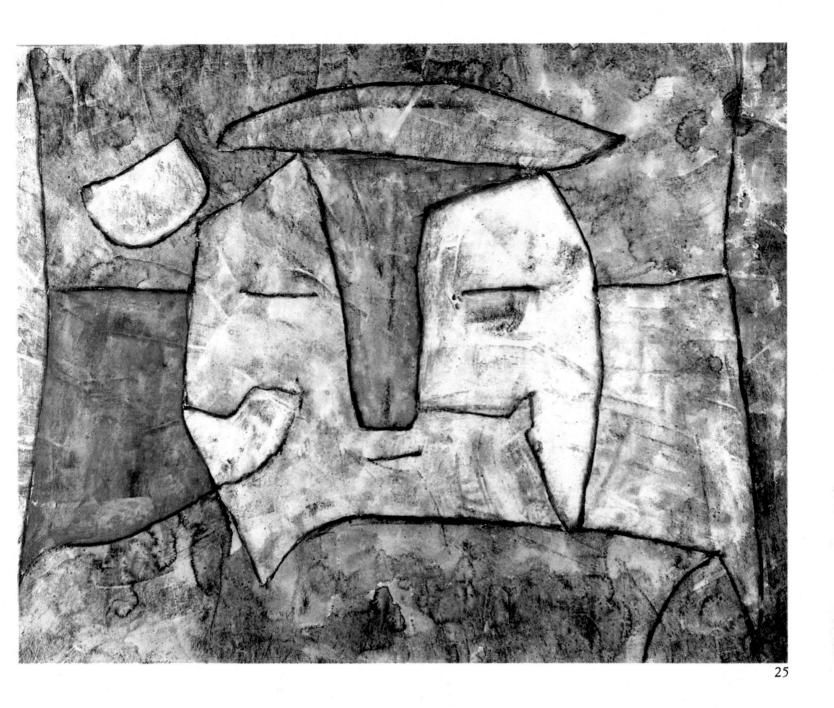

25

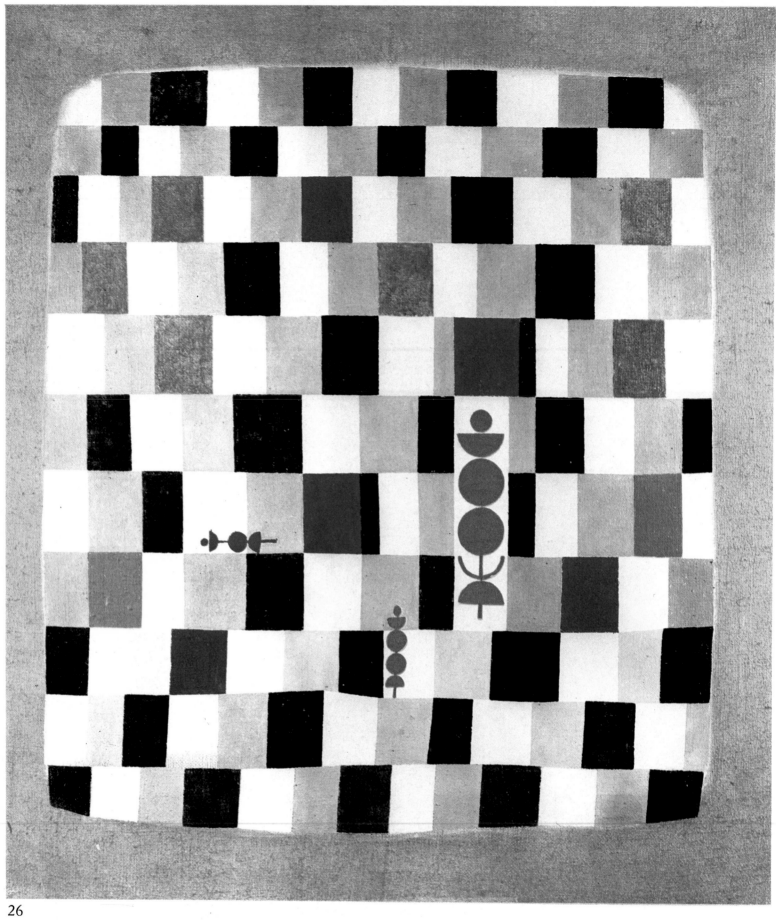

26

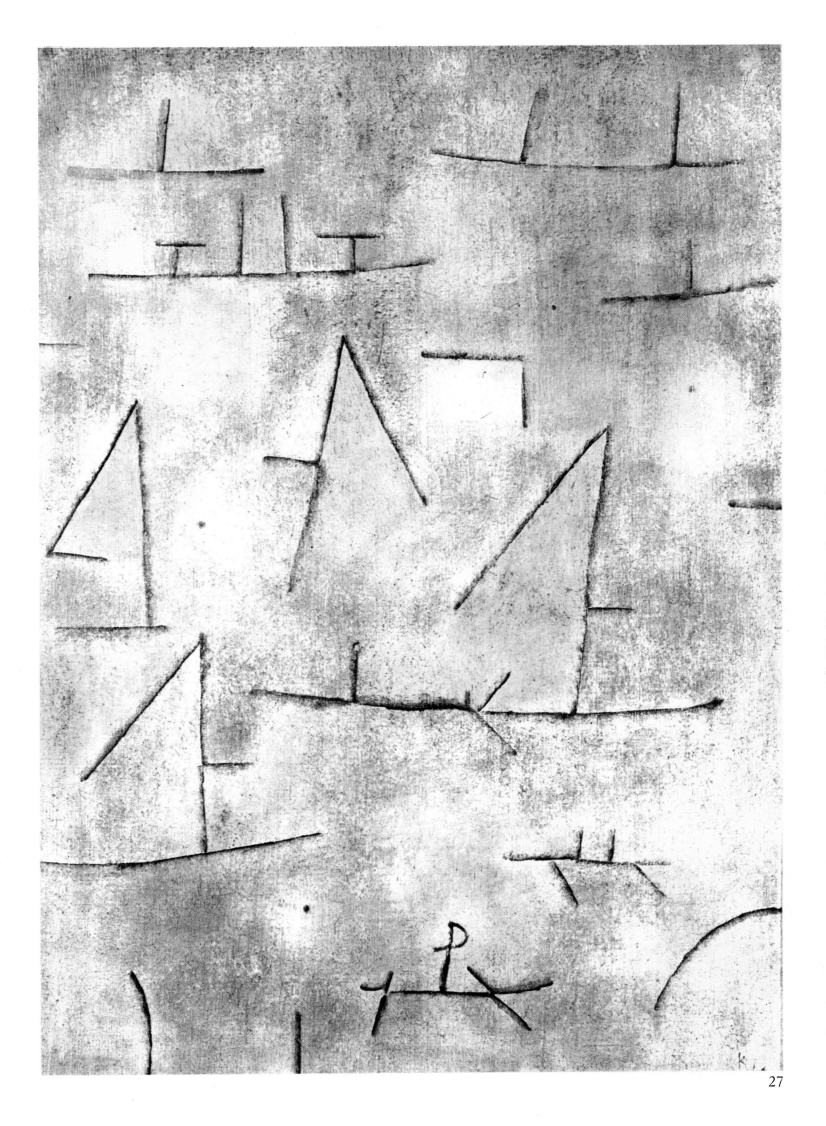

28-29

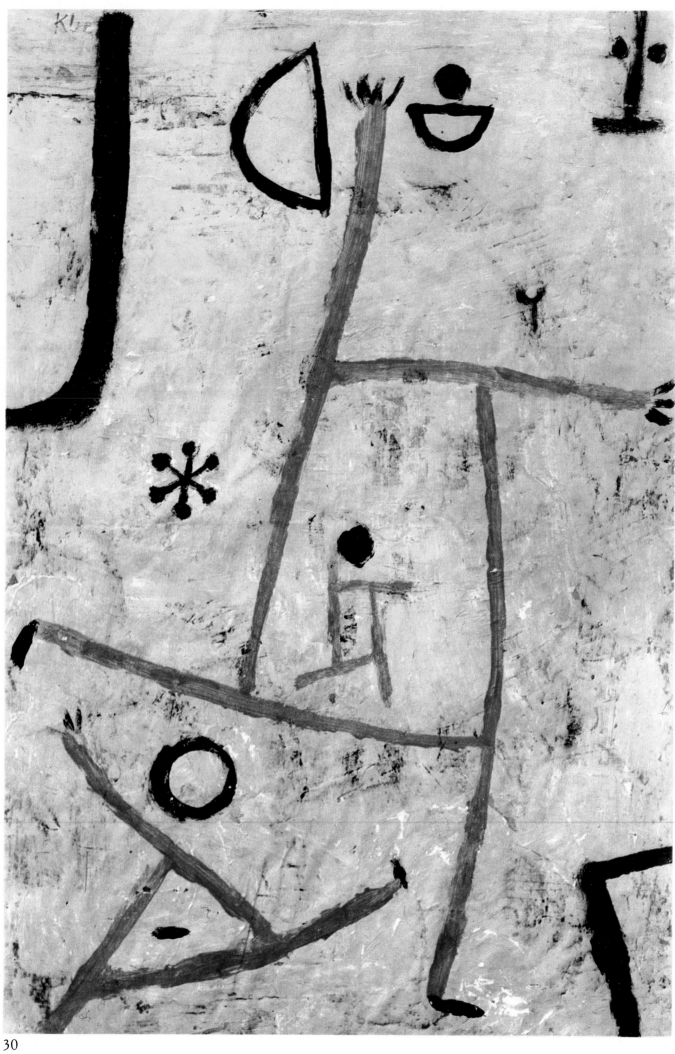

30

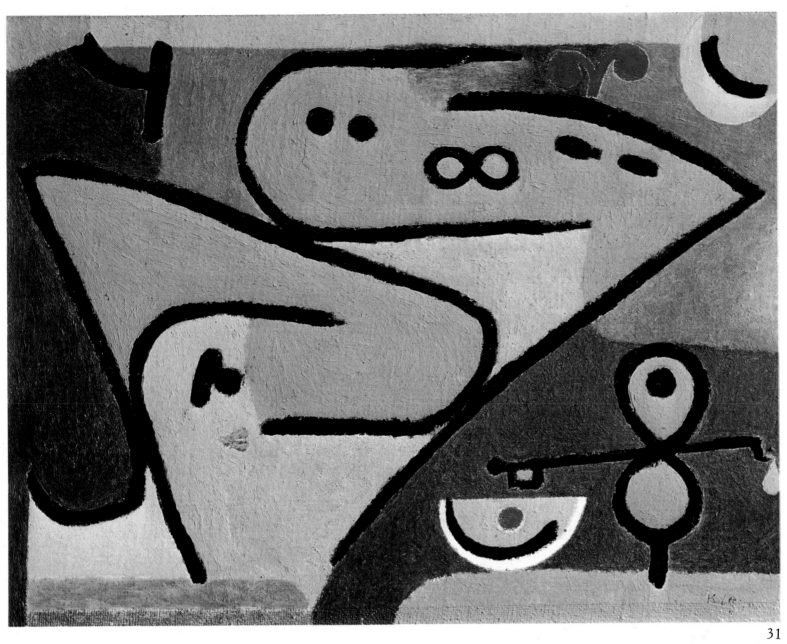

31

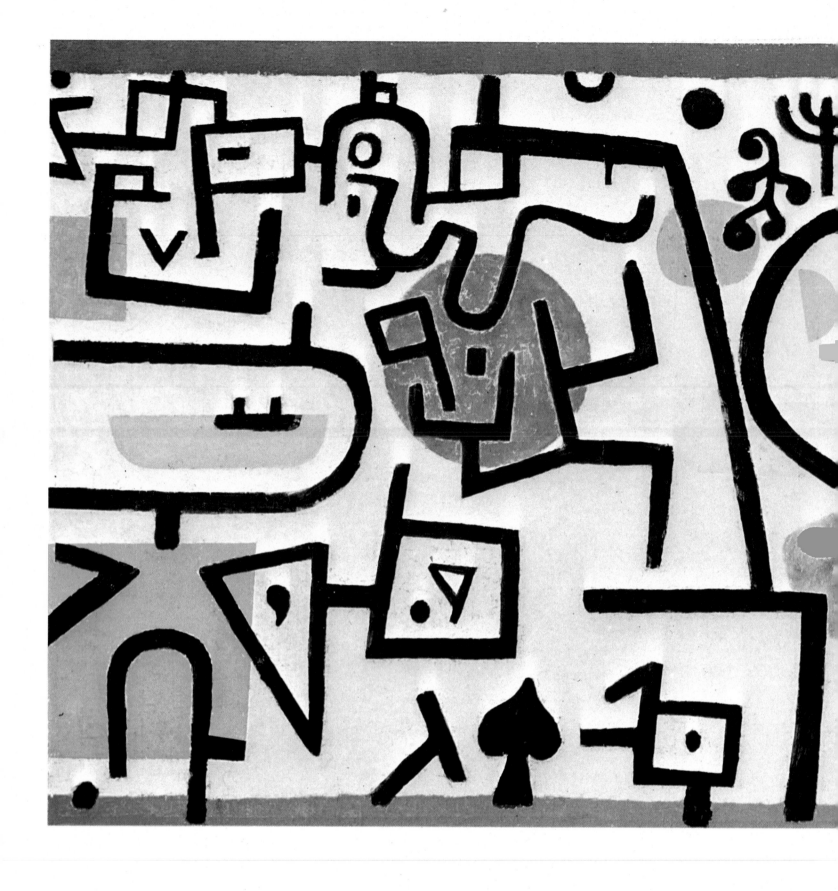

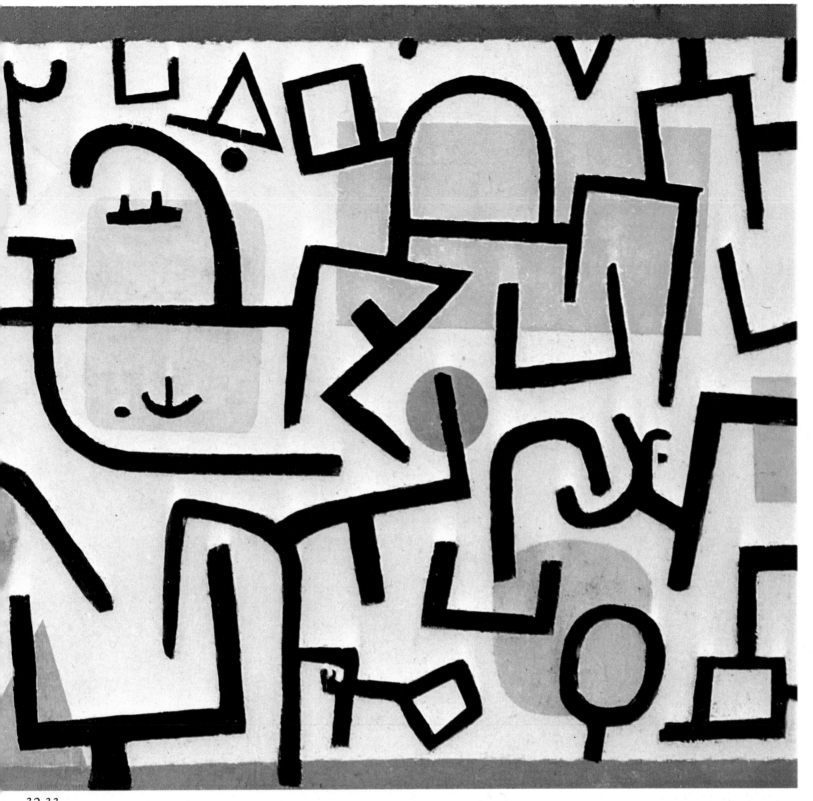

32-33

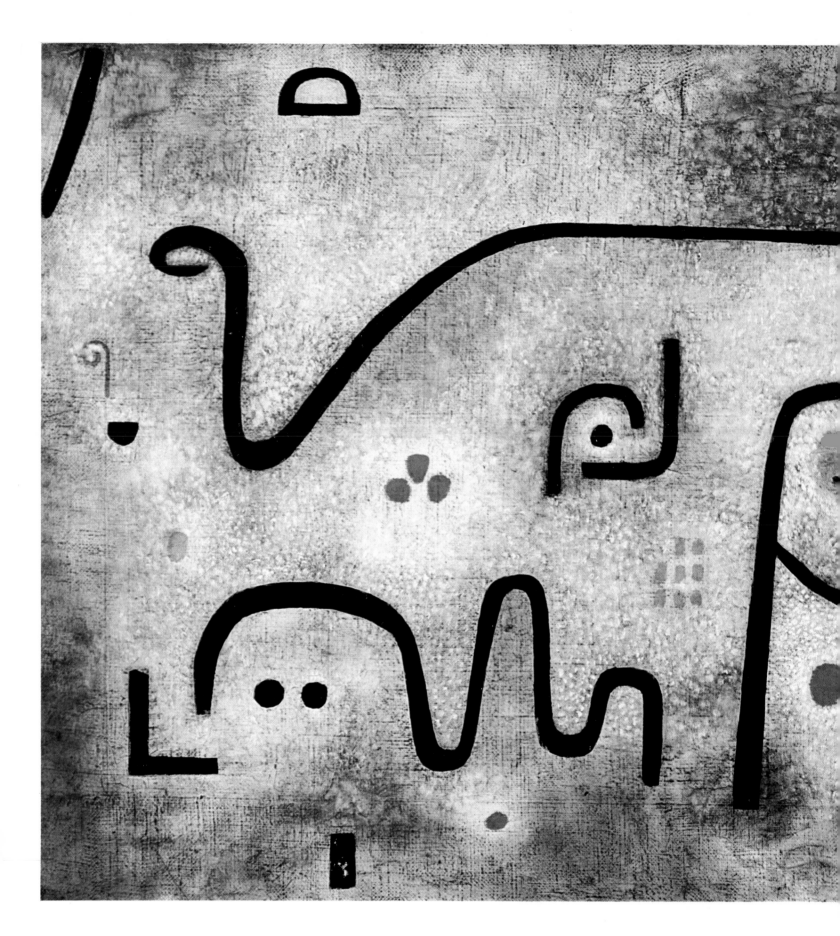

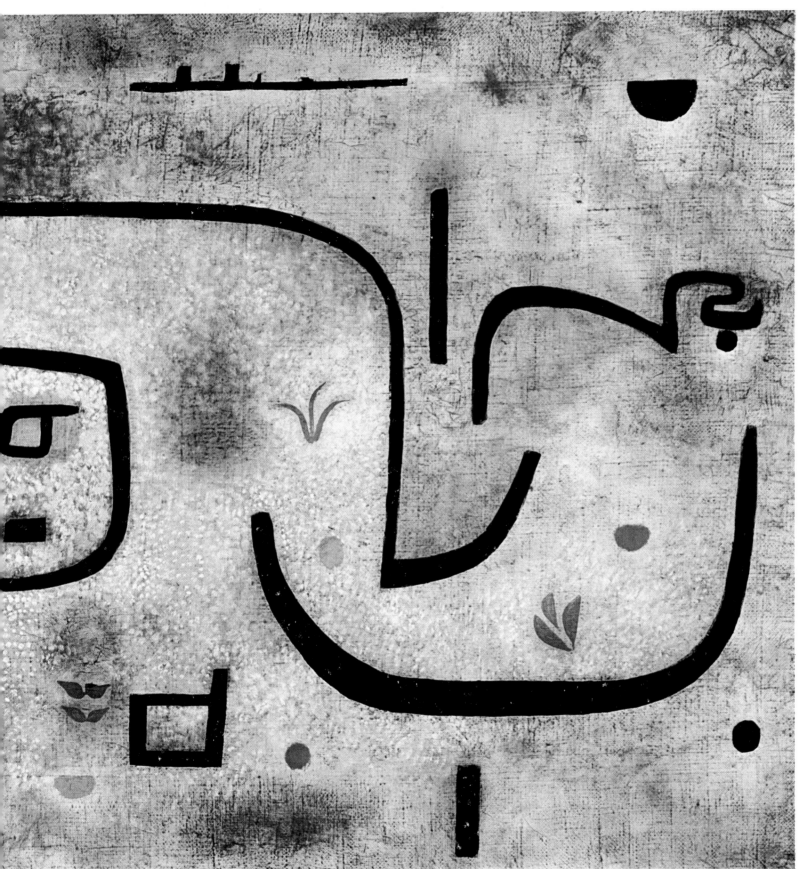

34-35

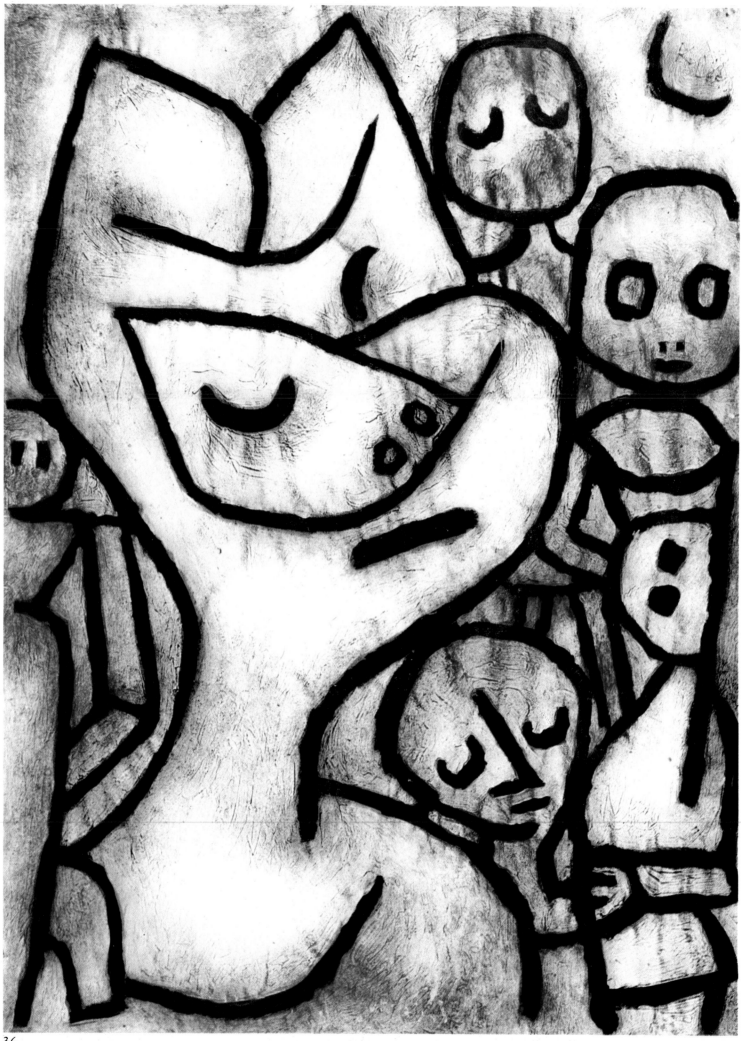

36

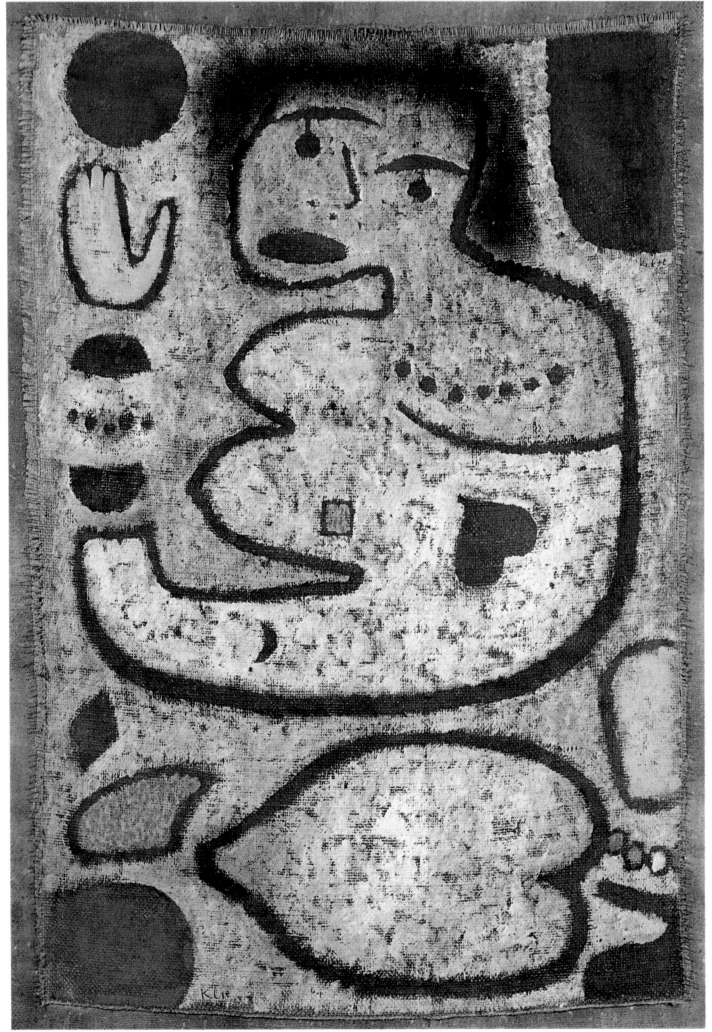

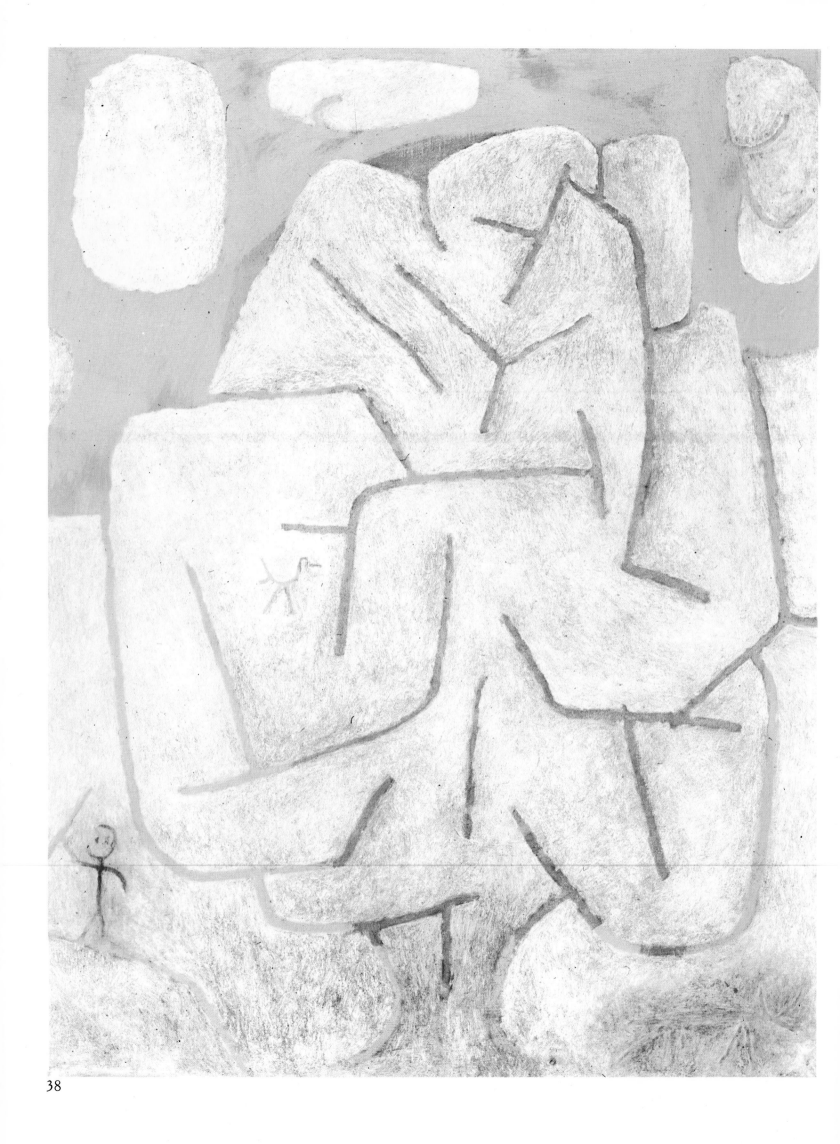

38

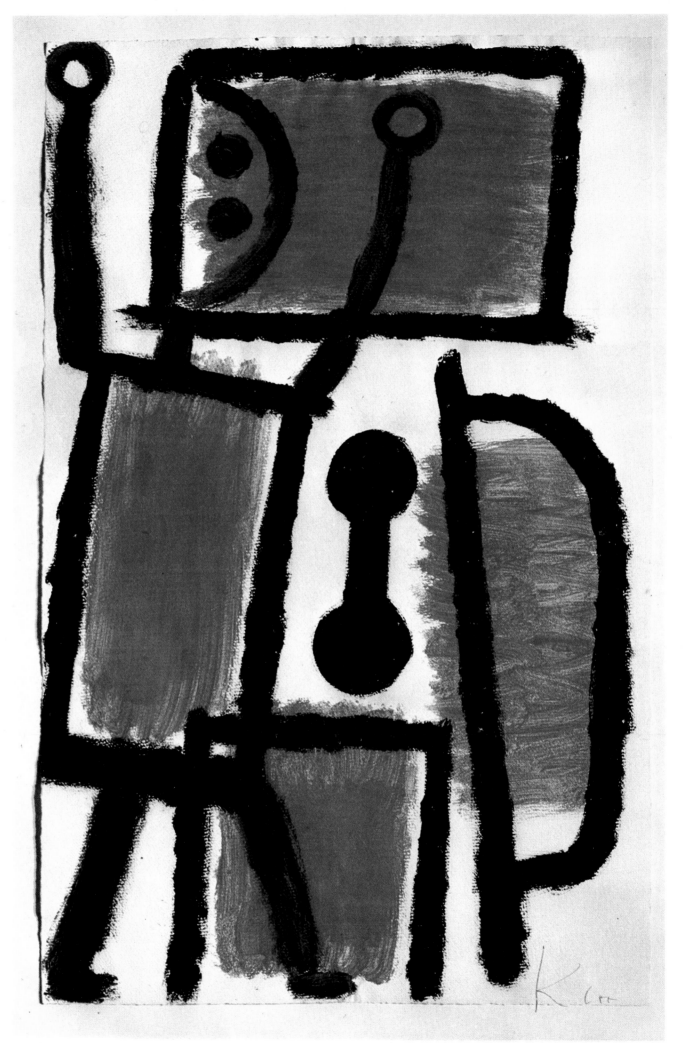

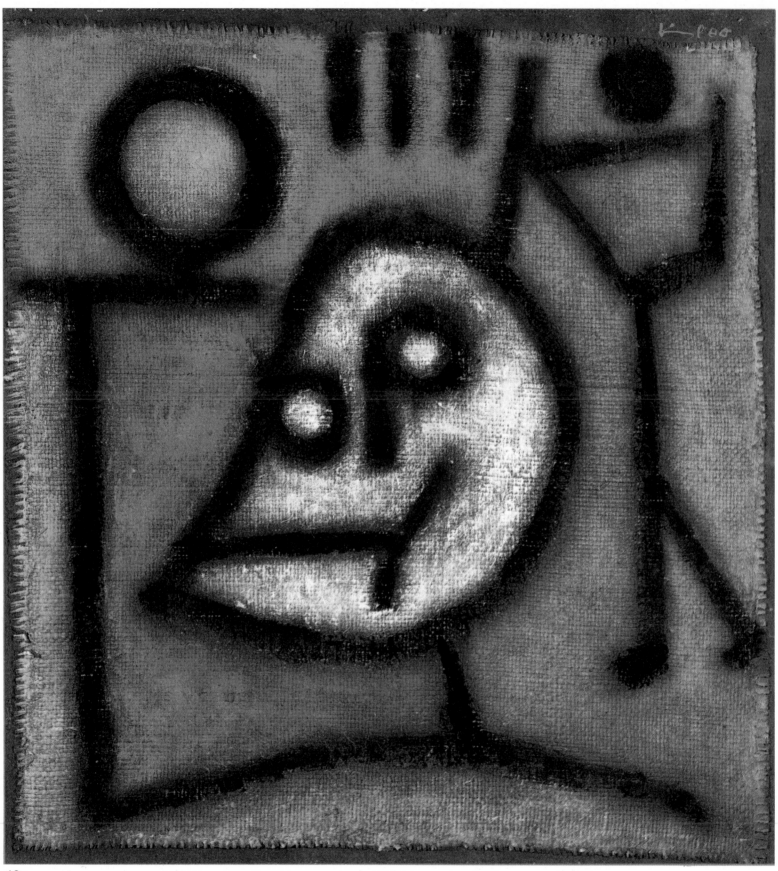

40

Description of colour plates

1 *Composition*
1914, tempera on cardboard, $10\frac{5}{8} \times 10$ in (27×25.2 cm)
Kunstmuseum, Basle

2 *With the gas lamp*
1915
Galleria d'Arte Moderna, Rome

3 *Already submerged in the greyness of night*
1918, watercolour, $9\frac{3}{4} \times 5\frac{7}{8}$ in (25×15 cm)
Paul Klee–Stiftung, Kunstmuseum, Berne

4 *Villa R*
1919, oil on cardboard, $8\frac{3}{4} \times 10\frac{1}{4}$ in (22×26 cm)
Kunstmuseum, Basle

5 *Small fir-tree*
1922, oil on canvas glued on cardboard,
$12\frac{1}{2} \times 7\frac{7}{8}$ in (31.5×20 cm)
Kunstmuseum, Basle

6 *Senecio*
1922, oil on canvas, $15\frac{7}{8} \times 15$ in (40.5×38 cm)
Kunstmuseum, Basle

7 *Mask with small flag*
1925, watercolour on paper, $25\frac{1}{2} \times 19\frac{3}{4}$ in (65×49.5 cm)
Neue Pinakothek, Munich

8 *Ancient sound (Abstract on a black background)*
1925, oil on cardboard, 15×15 in (38×38 cm)
Kunstmuseum, Basle

9 *Garden in P.H.*
1925, oil on cardboard, $20\frac{7}{8} \times 13\frac{3}{8}$ in (53×34 cm)
Formerly in the collection of Richard Doetsch–Benziger

10 *Portrait of Mr A. L.*
1925, pen and wash, 10×7 in (25.5×18 cm)
Kunsthaus, Zurich

11 *Idyll in a city garden*
1926, incised on plaster, coloured with tempera,
$16\frac{3}{4} \times 15\frac{1}{2}$ in (42.5×39.5 cm)
Kunstmuseum, Basle

12 *Steps and staircase*
1928, gouache, $5\frac{5}{8} \times 5\frac{5}{8}$ in (14.5×14.5 cm)
Musée National d'Art Moderne, Paris

13 *The spirit of the stalk*
1930, gouache, $13 \times 7\frac{1}{2}$ in (33×19 cm)
Musée National d'Art Moderne, Paris

14 *Ponderable relative*
1930, collage and gouache on paper, $13\frac{1}{8} \times 12\frac{1}{4}$ in (33.5×31 cm)
Boymans-van Beuningen Museum, Rotterdam

15 *Ad marginem*
1930, ink and wash, varnished on cardboard,
17×13 in (43.5×33 cm)
Kunstmuseum, Basle

16–17 *The crosses and the pillars*
1931, tempera on paper, $19\frac{1}{4} \times 26\frac{3}{4}$ in (49×68.2 cm)
Neue Pinakothek, Munich

18 *Vegetal-analytical*
1932, gouache on canvas, $13\frac{1}{8} \times 7\frac{1}{2}$ in (33.5×19 cm)
Kunstmuseum, Basle

19 *A gate of the M. garden*
1932, gouache on canvas impregnated with plaster,
covered with white gauze and painted, $12\frac{1}{4} \times 13$ in (31×33 cm)
Kunstmuseum, Basle

20 *Aunt and child*
1932, $28\frac{1}{2} \times 20\frac{5}{8}$ in (72.5×52.5 cm)
Bayeler Gallery, Basle

21 *Ad Parnassum*
1932, oil on canvas, $39\frac{3}{8} \times 50\frac{3}{8}$ in (100×128 cm)
Kunstmuseum, Berne

22–23 *Polyphony*
1932, tempera on canvas, $26\frac{1}{8} \times 41\frac{3}{4}$ in (66.5×106 cm)
Kunstmuseum, Basle

24 *Group of huts*
1932, $30\frac{1}{4} \times 22\frac{3}{4}$ in (77×58 cm)
Kunstmuseum, Basle

25 *St Anthony after the temptation*
1935, gouache, $15 \times 19\frac{3}{4}$ in (38.5×50 cm)
Kunstsammlung Nordrhein-Westfalen, Düsseldorf

26 *Outsize bag*
1937, oil on canvas, $49\frac{1}{4} \times 43\frac{1}{4}$ in (125×110 cm)
Kunsthaus, Zurich

27 *Port and sailing boats*
1937, oil on canvas, $31\frac{1}{2} \times 23\frac{5}{8}$ in (80×60 cm)
Musée National d'Art Moderne, Paris

28–29 *Blue night*
1937, tempera and pastel on canvas, $19\frac{3}{4} \times 30$ in (50.5×76.5 cm)
Kunstmuseum, Basle

30 *With special heads*
1938, tempera and paint with glue on paper,
$19 \times 12\frac{3}{4}$ in (48.5×32.5 cm)
Boymans-van Beuningen Museum, Rotterdam

31 *Aeolian*
1938, oil on canvas, $20\frac{1}{2} \times 26\frac{3}{4}$ in (52×68 cm)
Kunstmuseum, Berne

32–33 *Flourishing port*
1938, tempera on paper and canvas, $29\frac{1}{2} \times 65$ in (75×165 cm)
Kunstmuseum, Basle

34–35 *Insula Dulcamara*
1938, oil on canvas, $34\frac{5}{8} \times 68\frac{7}{8}$ in (88×175 cm)
Paul Klee–Stiftung, Kunstmuseum, Berne

36 *Attitude of a face, I*
1939, gouache and plaster on paper, $23\frac{5}{8} \times 17\frac{1}{2}$ in (60×44.7 cm)
Kunsthaus, Zurich

37 *Love song under the new moon*
1939, watercolour on canvas, $39\frac{3}{8} \times 30\frac{1}{4}$ in (100×77 cm)
Paul Klee–Stiftung, Kunstmuseum, Berne

38 *At the hunter's tree*
1939, oil on canvas, $39\frac{3}{8} \times 31\frac{1}{2}$ in (100×80 cm)
Kunsthaus, Zurich

39 *Magnano*
1940, tempera with flour and glue on paper,
$18\frac{7}{8} \times 12\frac{1}{8}$ in (48×31 cm)
Kunstmuseum, Basle

40 *Death and the fire*
1940, oil on canvas, $18\frac{1}{8} \times 17\frac{1}{4}$ in (46×44 cm)
Paul Klee–Stiftung, Kunstmuseum, Berne

Biographical outline

1879. Paul Klee is born December 18th at Münchenbuchsee near Berne, to Hans Klee, musician, and Ida Maria Frich.

1898. He passes his school-leaving exams at the High School in Berne.

1898–1901. He works with Heinrich Knirr and attends Franz von Stück's classes at the Academy in Munich, and makes his first etchings.

1901–1902. June 30th, 1901, he leaves for Italy with the sculptor Hermann Haller; passes through Milan and Genoa and is in Rome on October 27th; next spring he is in Naples. He returns to Berne on May 7th. In Munich, becomes engaged to the pianist Lily Stumpf.

1903–1905. He makes ten etchings entitled 'Inventions'.

1904. On a visit to Munich he discovers and studies the works of Beardsley, Blake and Goya, and in Geneva those of Corot.

1905. Visits Paris with Bloesch and Moilliet, where he is deeply impressed by the work of Leonardo. He begins painting on glass.

1906. In April he pays a short visit to Berlin. He exhibits some etchings at the Sezession in Munich. In September he marries Lily Stumpf and moves to Munich.

1907. November 30th, his son Felix is born. He discovers the drawings of James Ensor.

1908. He exhibits several works in the Sezession of Munich and Berlin, and in the Glaspalast in Munich. He discovers the work of Van Gogh at exhibitions at the Zimmermann and Brakl galleries. Paints on glass and executes a number of watercolours and drawings.

1909. He discovers the work of Cézanne at the Sezession and that of Matisse at the Tannhäuser.

1910. He exhibits 56 works, from 1907 to 1910, at the Berne museum; other exhibitions at Zurich, Basle and Winterthur.

1911. First contacts with the Blaue Reiter group. He works on illustrations for Voltaire's *Candide,* which is published in 1920; begins the retrospective catalogue of his work from 1899; meets and sees a lot of Macke, Kubin, Marc, Kandinsky, Jawlensky, Campendonk, Münter, Werefkin and Arp.

1912. Exhibits four drawings at the Sonderbund in Cologne, and at the Kunsthaus and Moderner Bund in Zurich. In March he takes part in the second exhibition of the Blaue Reiter. At the Tannhäuser he sees the Futurists. From April 2nd–18th he is in Paris, where he meets Delaunay, Kahnweiler and Uhde, and sees paintings by Picasso, Braque and the Douanier Rousseau.

1913. Exhibits at Der Sturm gallery in Berlin and takes part in the first German autumn salon in the same gallery.

1914. He is present at the founding of the Neue Münchner Sezession. From April 5th–27th he is in Tunisia with Louis Moilliet and August Macke. He visits Saint-Germain, Carthage, Hammamet and Kairouan, and comes home via Italy. Watercolours predominate in the work of this period. War breaks out on August 1st but Klee's work continues.

1916–1918. He joins the army, after being called up.

1919. He signs a contract with Goltz for three years, which will be renewed till 1925.

1920. In the spring, Goltz exhibits 262 of Klee's works in his gallery. The review *Ararat* publishes a special number with a catalogue of the exhibition. 'Schöpferische Konfession' (The Creative Confession) is published in the review *Tribune der Kunst und Zeit.* The editor Kurt Wolff publishes *Candide* with Klee's illustrations. On November 22nd he receives a telegram signed by Gropius, Feininger, Engelmann, Marcks and Muche, offering him a post teaching painting at the Bauhaus.

1921. In January he moves to Weimar and begins teaching at the Bauhaus. His mother, Ida Maria Frich, dies.

1923. He publishes 'Wege des Naturstudiums' (The Study of Nature), in the collection called *Staatliches Bauhaus* in Weimar 1919–1923. He exhibits at the Kronprinzenpalast in Berlin and spends the summer on the island of Baltrum.

1924. First exhibition in America, in New York. He visits Sicily; since his trip to Tunisia, he had considered the South his true country.

He gives a lecture at Jena on modern art, which is published in 1945. December 22nd, the Bauhaus ceases its activity in Weimar.

1925. In April the Bauhaus moves to Dessau. From June, Klee and his family share a house, divided into two flats, with Vassily and Mina Kandinsky. In the Bauhaus-Bücher series, *Pädagogisches Skizzenbuch* appears. Klee takes part in the Surrealists' exhibition in Paris. Second exhibition in the Goltz gallery in Munich and first exhibition at the Vavin-Raspail gallery in Paris.

1926. In June he moves to Dessau. Visits Italy in the summer: Elba, Florence, Pisa, Ravenna.

1927. In the summer he visits the islands of Porquerolles and Corsica.

1928. Travels to Brittany. From December 1928 to January 1929 he is in Egypt.

1929. At the Flechtheim gallery in Berlin he has a large exhibition to celebrate his fiftieth birthday. Will Grohmann publishes his first monograph on Klee in the Cahiers d'Art series.

1930. The Museum of Modern Art in New York takes over the exhibition from Berlin. Klee stays in the Engadine and at Viareggio. Another exhibition at Dresden, Düsseldorf and Saarbrücken.

1931. He accepts a post at the academy in Düsseldorf. Returns to Sicily in the summer.

1932. Travels to Venice and northern Italy.

1933. Travels to France. Decides to move to Berne, because of his strong opposition to the Nazis.

1934. First exhibition in England, at the Mayor gallery in London. Will Grohmann publishes some of Klee's drawings, but the edition is seized by the Gestapo.

27 Drawing of Lily Stumpf 1905

28 *Profound meditation*, self-portrait, 1916

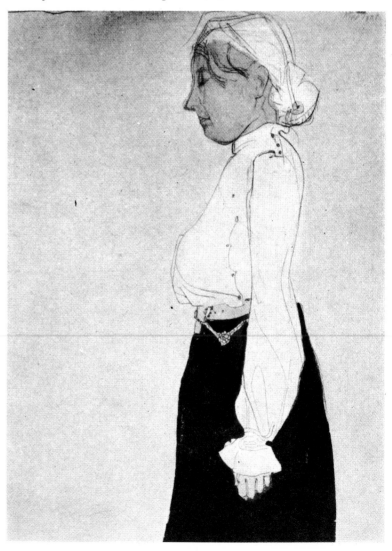

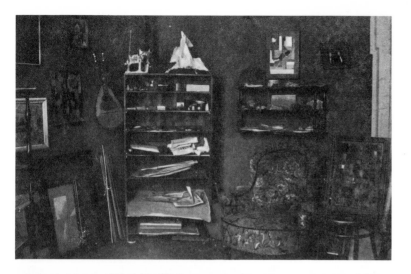

1935. The Kunsthaus in Berne holds a retrospective exhibition, which is later transferred to Basle. First signs of the illness that was finally to kill Klee.
1936. Exhibition at Lucerne.
1937. Picasso and Braque visit Klee's studio in Berne. In Munich, seventeen of Klee's works appear in the exhibition of degenerate art organised by the Nazis.
1938. Exhibitions in New York and Paris.
1939. Klee is sixty. He paints the series of 'Angels'.
1940. Large exhibition of the works from 1935–1940 appears at the Kunsthaus in Zurich. Klee's father dies. On May 10th, Klee's own condition deteriorates, and on June 29th he dies at Muralto–Locarno.

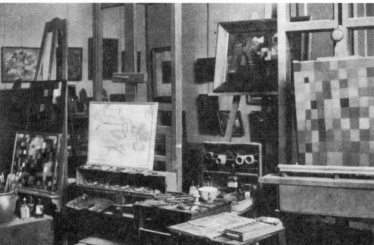

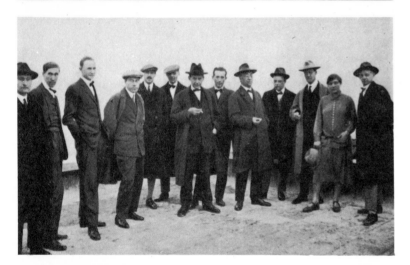

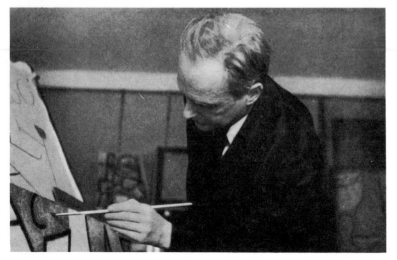

29 The artist's studio in Munich, 1920

30 The artist's studio at Weimar, 1924

31 Members of the Bauhaus at Dessau, 1926. From left to right: Albers, Scheper, Muche, Moholy-Nagy, Bayer, Schmidt, Gropius, Breuer, Kandinsky, Klee, Feininger, Gunda Stölzl, Schlemmer

32 Paul Klee in 1938

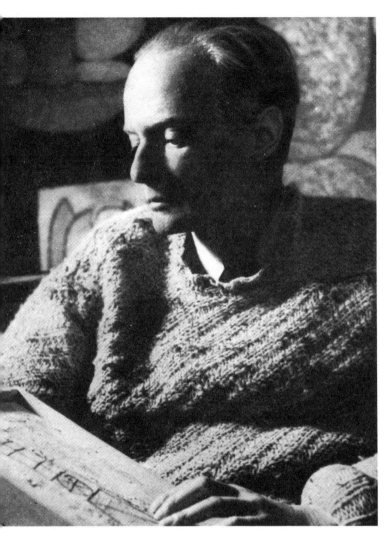

3 Paul Klee in Berne in 1940, a few months before his death

Bibliography

W. LANG, 'Die Walze', in *Die Schweiz*, Zurich 1908; H. BLOESCH, 'Ein moderner Grafiker: Paul Klee' in *Die Alpen*, no. 5, Berne 1912; J. MEIERGRAEFE, *Entwicklungsgeschichte der modernen Kunst*, 2 ed., Munich 1915; A. BEHNE, *Paul Klee*, in *Die Weissen Blätter*, 4, no. 5, Zurich 1917; E. CARO, article on 'Klee' in C. BRUN, *Schweizerisches Künstlerlexikon*, 4, supplementary, Frauenfeld 1917; W. Michel, *Das Teuflische und Groteske in der Kunst*, Munich 1917; T. DÄUBLER, 'Paul Klee', in *Das Kunstblatt*, 2, Weimar 1918; T. DÄUBLER, 'Paul Klee', in *Neue Blätter für Kunst und Dichtung*, 1, Dresden 1918; H. WALDEN, *Expressionismus: die Kunstwende*, Berlin 1918; *Paul Klee*, in the series 'Sturm Bilderbücher', no. 3, Berlin 1918; T. DÄUBLER, 'Paul Klee', in *Das Junge Deutschland*, 2, Berlin 1919; W. JOLLOS, 'Paul Klee', in *Das Kunstblatt*, 3, Potsdam 1919; W. MICHEL, 'Paul Klee', in *Das graphische Jahrbuch*, Darmstadt 1919; E. VON SYDOW, 'Paul Klee', in *Münchner Blätter für Dichtung und Graphik*, 1, no. 9, Munich 1919; L. STERN, 'Klee' in *Sozialistische Monatshefte*, 52, Berlin 1919; *Über Expressionismus in der Malerei*, Berlin 1919; 'Aus Stuttgart wird uns geschrieben', in *Kunstchronik und Kunstmarkt*, 55, Leipzig 1919–20; H. KAISER, 'Paul Klee', in *Das hohe Ufer*, 2, Hanover 1920; K. PFISTER, *Deutsche Graphiker der Gegenwart*, Leipzig 1920; R. SCHACHT, 'Paul Klee', in *Freie Deutsche Bühne*, 1, nos. 30–31, Berlin 1920; E. VON SYDOW, *Die deutsche expressionistische Kultur und Malerei*, Berlin 1920; W. UHDE, 'Brief (an Edwin Suermondt)', in *Die Freude*, 1, 1920; H. VON WEDDERKOP, *Paul Klee*, Leipzig 1920; W. WOLFRADT, 'Der Fall Klee', in *Freie Deutsche Bühne*, 1, no. 52, Berlin 1920; L. ZAHN, 'Paul Klee', in *Valori Plastici*, 2, nos. 7–8, Rome 1920; L. ZAHN, *Paul Klee: Leben, Werk, Geist*, Potsdam 1920; G. F. HARTLAUB, 'Wie ich Klee sehe', in *Feuer*, 2, Weimar 1920–21; F. Gurlitt, *Das graphische Jahr*, Berlin 1921; W. Hausenstein, *Kairuan, oder eine Geschichte vom Maler Klee und von der Kunst dieses Zeitalters*, Munich 1921; H. KOLLE, 'Paul Klee', in *Der Ararat*, 2, Munich, 1921; H. KOLLE, 'Über Klee, den Spieltrieb und das Bauhaus', in *Das Kunstblatt*, 6, Potsdam 1922; P. E. KÜPPERS, 'Die Sammlung Max Leon Flemming in Hamburg', in *Der Cicerone*, 14, no. 1, Leipzig 1922; W. GROHMANN, 'Paul Klee, 1923–1924', in *Der Cicerone*, 16, no. 17, Berlin 1924; H. WALDEN, 'Einblick in Kunst', Berlin 1924; W. GROHMANN, 'Handzeichnungen von Paul Klee', in *Monatshefte für Bücherfreunde und Graphiksammler*, 1, no. 5, Leipzig 1925; C. EINSTEIN, *Die Kunst des 20. Jahrhunderts*, 2nd ed., Berlin 1926; P. ÉLUARD, 'Paul Klee', in *Capitale de la douleur*, Paris 1926; A. LHOTE, 'L'exposition Klee', in *Nouvelle Revue Française*; H. BALL, *Die Flucht aus der Zeit*, 1, ed., Munich–Leipzig 1927, 2nd ed., Lucerne 1945; L. SCHEEWE, 'Klee', in Thieme–Becker, *Allgemeines Lexikon der bildenden Künstler*, vol. 20, Leipzig 1927; J. CASSOU, 'Paul Klee' in *Feuilles Libres*, 9, no. 48, Paris 1928; W. GROHMANN, 'Paul Klee' in *Cahiers d'Art*, 3, no. 7, Paris 1928; J. MILO, 'Paul Klee', in *Cahiers de Belgique*, 1, Brussels 1928; W. GROHMANN, *Paul Klee*, Paris 1929; F. W. HALLE, 'Dessau: Burgkühnauer Allee 6–7 (Kandinskij und Klee)', in *Das Kunstblatt*, 13, Berlin 1929; G. LIMBOUR, 'Paul Klee' in *Documents*, 1, Paris 1929; G. MARLIER, 'Paul Klee', in *Cahiers de Belgique*, 2, Brussels 1920; K. SCHEFFLER, 'Paul Klee: Ausstellung in der Galerie Alfred Flechtheim' in *Kunst und Künstler*, 28, Berlin 1929; M. SEIZE, 'Paul Klee', in *Art d'Aujourd'hui*, 6, no. 22, Paris 1929; W. UHDE, *Picasso and the French tradition*, Paris and New York 1929; R. ARNHEIM, 'Klee für Kinder', in *Die Weltbühne*, 26, Berlin 1930; R. CREVEL, *Paul Klee*, Paris 1930; E. L. KIRCHNER, 'Randglossen zum Aufsatz: Klee für Kinder', in *Das Kunstblatt*, 14, Berlin 1930; J. KLEIN, 'Line of Introversion', in *New Freeman*, 1, no. 4, New York 1930; H. F. JEIST, 'Kinder über Paul Klee', in *Das Kunstblatt*, 14, Berlin 1930; A. J. SCARDT, 'Das Übersinnliche bei Paul Klee', in *Museum der Gegenwart*, 1, Berlin 1930; R. VITRAC, 'A propos des oeuvres récentes de Paul Klee', in *Cahiers d'Art*, 5, Paris 1930; L. JUSTI, *Von Corinth bis Klee*, Berlin 1931; F. WESTHEIM, *Helden und Abenteurer: Welt und Leben des Künstlers*, Berlin 1931; *Bauhaus; Zeitschrift für Gestaltung* (special number on Klee with contributions by Kandinsky, Grohmann, Hestel), Dessau 1931; H. KLUMPP, *Abstraktion in der Malerei, Kandinskij, Feininger, Klee*, Berlin 1932; H. READ, *The Anatomy of Art*, New York 1932; *Zeitschrift für Gestaltung* (special number on Klee), ed. Bauhaus, Dessau 1932; W. GROHMANN, *Die Sammlung Ida Bienert*, Potsdam 1933; F. COSSIO DEL POMAR, *Nuevo arte*, Buenos Aires 1934; G. GRISSON, 'Paul Klee', in *The Bookman*, 85, London 1934; W. GROHMANN, *Handzeichnungen, 1921–1930*, Potsdam–Berlin 1934; H. READ, *Art Now*, New York 1934; H. SCHIESS, 'Notes sur Klee à propos de son exposition à la Galerie Simon', in *Cahiers d'Art*, 9, nos. 5–8, Paris 1934; G. GRIGSON, *The Arts Today*, London 1935; W. GROHMANN, 'Klee at Berne', in *Axis*, no. 2, London 1935; W. GROHMANN, 'Abschied von Klee', in *Werk*, 22, Winterthur 1935; R. HUYGHE, *Histoire de l'art contemporain: la peinture*, Paris 1935; C. J. BULLIET, *The significant Moderns and their Pictures*, New York 1936; P. ÉLUARD, 'Paul Klee', in *Thorns of Thunder*, London 1936; 'Paul Klee', in *Art Lover*, 3, no. 1, edited by J. B. Neumann, New York 1936; J. A. THWAITES, 'Paul Klee and the Object', in *Parnassus*, 9, nos. 6–7, New York 1937; W. WILLRICH, *Säuberung des Kunsttempels: eine Kunstpolitische Kampfschrift zur Gesundung deutscher Kunst im Geiste nordischer Art*, Munich–Berlin 1937; R. J. GOLDWATER, *Primitivism in Modern Painting*, New York 1938, ed. 1968; W. GROHMANN, 'L'Art contemporain en Allemagne', in *Cahiers d'Art*, 13, nos. 1–2, Paris 1938; 'Homage to Paul Klee', in *XXᵉ Siècle*, articles by H. Read and P. Courthion, no. 4, Paris 1938; P. THOENE, *Modern German Art*, London 1938; C. ZERVOS, *Histoire de l'art contemporain*, Paris 1938; R. TODD, 'Paul Klee', in *London Bulletin*, no. 12, London 1939; H. G. BAYNES, *Mythology of the Soul: A Research into the Unconscious from Schizophrenic Dreams and Drawings*, Baltimore 1940; R. BERNOULLI, *Mein Weg zu Klee, Randbemerkungen zu einer Ausstellung seines graphischen Werkes in der Eidg. graphischen Sammlung in Zürich, 1940*, Berne 1940; M. BILL, 'Paul Klee' in *Das Werk*, 27, Zurich 1940; H. BLOESCH and G. SCHMIDT, *Paul Klee; Reden zu seinem Todestag, 29, Juni 1940*, Berne 1940; R. Todd, 'Paul Klee 1879–1940', in *Horizon*, 2, no. 12, London 1940; S. CHENEY, *The Story of Modern*

Art, New York 1941; C. GREENBERG, 'On Paul Klee 1879–1940', in *Partisan Review*, 8, no. 3, New York 1941; K. NIERENDORF, *Paul Klee, Paintings, Watercolours, 1913 to 1939*, New York 1941; G. OERI, 'W. K. Wiemken und Paul Klee', in *Werk*, 28, no. 11, Winterthur 1941; A. J. SCHARDT, 'Paul Klee', in *California Arts and Architecture*, 58, San Francisco 1941; J. ADLER, 'Memories of Paul Klee', in *Horizon*, 6, no. 34, London 1942 (also *in Kroniek van Kunst en Kultuur*, 8, nos. 7–8, with the title *Herinneringen aan Paul Klee*, Amsterdam 1947); R. FROST, 'Klee: Pigeons Come Home to Roost', in *Art News*, 41, New York 1942; P. GUGGENHEIM, *Art of this Century*, New York 1942; H. M. KALLEN, *Art and Freedom*, New York 1942; 'Polyphonic Architecture', in *St Louis Museum Bulletin*, 27, St Louis 1942; H. MEYER-BENTELI, 'Paul Klee, zu zwei Bildern', in *Werk*, 30, no. 7, Winterthur 1943; R. M. PEARSON, *Experiencing American Pictures*, New York 1943; E. BILLE, *Picasso, surréalisme, abstrakt Kunst*, Copenhagen 1945; A. BOSMAN, *Paul Klee in Memoriam*, The Hague 1945; F. FOSCA, *Histoire de la peinture suisse*, Geneva 1945; R. IRONSIDE, 'Paul Klee' in *Horizon*, 12, no. 72, London 1945; K. KEYNES, 'Paul Klee' in *Collected Poems*, London 1945; E. M., 'Autour de Paul Klee', in *Labyrinthe*, no. 11, Geneva 1945; G. DI SAN LORENZO, *Cinquant'anni di pittura moderna in Francia*, Rome 1945; H. SCHWETZOV, 'Poems to two paintings by Paul Klee: The School Girl, Actor's Mask', in *Accent*, 5, no. 2, New York 1945; S. SHIPLEY, 'Travelling Circus', in *Baltimore Museum of Art News*, 7, no. 7, Baltimore 1945; J. T. SOBY, *The Prints of Paul Klee*, New York 1945; *Cahiers d'Art*, 20–21 (special numbers with articles by C. Zervos, G. Duthuit, P. Mabille, T. Tzara, J. Bousquet, G. Batille, R. Vitrac, W. Grohmann, V. Hugo, poems by R. Clair and J. Prévert), Paris 1945–46; S. W. HAYTER, 'Paul Klee, Apostle of Empathy', in *Magazine of Art*, 39, Washington 1946; A. MASSON, 'Éloge de Paul Klee', in *Fontaine*, no. 53, Paris 1946; G. REYNOLDS, *Twentieth Century Drawings*, London 1946; G. SCHMIDT, *Ten Reproductions in Facsimile of Paintings by Paul Klee*, New York 1946; K. VAUGHAN, 'At the Klee Exhibition', in *New Writing and Daylight*, London 1946; G. F. HARTLAUB, *Die Graphik des Expressionismus in Deutschland*, Stuttgart 1947; H. MEYER-BENTELI, 'Omaggio a Klee', in *Domus*, no. 218, Milan 1947; L. VENTURI, *Pittura contemporanea*, Milan 1947; B. ALFIERI, *Paul Klee*, Venice 1948; Z. N. ARNOSTAVA, 'Paul Klee' in *Blok P*, 2, no. 8, Brno 1948; R. G. BRUHL, 'Paul Klee y sus ideas sobre el arte moderno', in *Ver y Estimar*, I, no. 4, Buenos Aires 1948; *Du*, 8, no. 10, (special number on Klee with contributions by A. Kübler, M. Huggler, F. Klee, R. Bürgi, A. Zschokke, C. Halter, W. Überwasser, R. Thiessing, M. Frey-Surbek), Zurich 1948; M. FREY-SURBEK, 'Berne Switzerland 1904. With the Klee Family', in *Right Angle*, 2, no. 9, Washington 1948; H. F. GEIST, *Paul Klee*, Hamburg 1948; C. GIEDION 'Klee', in *Mechanization Takes Command*, New York 1948; C. GIEDION-WELCKER, 'Bildinhalte und Ausdrucksmittel bei Paul Klee' in *Werk*, 35, no. 3, Winterthur 1948; W. HAFTMANN, 'Über das "humanistische" bei Paul Klee' in *Prisma*, no. 17, Munich 1948; T. HERZOG, *Einführung in die moderne Kunst*, Zurich 1948; *Homenaje a Paul Klee*, with short texts by A. Ferrant, M. Goeritz, J. Llorens Artigas, S. Nyberg, P. Palazuelo, B. Palencias, Madrid 1948; M. HUGGLER, 'Paul Klee. Auszug aus der Ausprache . . . zur Eröffnung der Ausstellung der Paul Klee Stiftung 22. November im Kunstmuseum, Berne', in *Kunst und Volk*, 10, no. 1, Zurich 1948; W. JÄGGI, 'Paul Klee: Wort, Bild, Ton', in *Die Bunte Maske*, 4, 1948; D. H. Kahnweiler, 'Apropos ett föredrag av Paul Klee', in *Konstrevy*, 24, no. 1, Stockholm 1948; F. KLEE, *Paul Klee: 22 Zeichnungen*, Stuttgart 1948; H. KNOLLE, 'Malerei des Unbewussten. Paul Klee zum Gedächtnis', in *Aufbau*, 4, no. 11, Berlin 1948; H. MARWITZ, 'Paul Klee, Maler zwischen den Zeiten', in *Der Ruf*, no. 9, Munich 1948; F. NEMITZ, 'Paul Klee' in *Deutsche Malerei der Gegenwart*, Munich 1948; E. PENZOLDT, 'Zu einem Aquarell von Paul Klee', in *Das Kunstwerk*, 2, no. 8, Baden-Baden 1948; H. READ, *Klee 1937–1940*, London 1948; W. ROTZLER, 'Klee', in B. Dorival, *Les peintres célèbres*, Geneva 1948; G. SCHMIDT, *Paul Klee: Ten Facsimile Reproductions of Works in Watercolour and Tempera*, Basle 1948; J. T. SOBY, *Contemporary Painters*, New York 1948; G. VERONESI, 'Paul Klee', in *Emporium*, 108, nos. 613–614, Bergamo 1948; M. ARLAND, *Chronique de la peinture moderne*, Paris 1949; J. CASSOU, 'Paul Klee', in *Architecture d'Aujourd'hui*, no. 2, Boulogne 1949; D. COOPER, *Paul Klee*, London 1949; W. GAUNT, *The March of the Modern*, London 1949; H. F. GEIST, 'Paul Klee', in *Rheinischer Merkur*, no. 5, Koblenz 1949; K. O. HANSON, 'Dance You Monster to My Sweet Song', in *Tiger's Eye*, no. 7, New York 1949; D. HAUTH-TRACHSLER, 'Zum Kopfschütteln über Paul Klee', in *WBK Mitteilungen*, no. 1, Zurich 1949; G. KADOW, 'Paul Klee and Dessau in 1929', in *College Art Journal*, 9, no. 1, New York 1949; *Paul Klee, 1. Teil: Dokumente und Bilder aus den Jahren 1896–1930*, Klee-Gesellschaft, Berne 1949; A. LEEPA, *The Challenge of Modern Art*, New York 1949; M. POLVER, 'Erinnerungen an Paul Klee', in *Das Kunstwerk*, 3, no. 4, Baden-Baden 1949; M. RABE, 'Rhythmus der Bäume: Erläuterungen zu dem Werk Paul Klees', in *Die Zeit*, 4, no. 4, Hamburg 1949; P. O. RAVE, *Kunstdiktatur im 3. Reich*, Hamburg 1949; W. WINKLER, *Psychologie der Modernen Kunst*, Tübingen 1949; *Dokumente und Bilder aus den Jahren 1896–1930*, (edited by Klee-Gesellschaft), Berne 1949; M. ARMITAGE, *5 Essays on Klee*, New York 1950; 'Aspects of the Art of Paul Klee', in *Museum of Modern Art Bulletin*, 17, no. 4, New York 1950; H. BEENKEN, 'Nachkriegsliteratur über Klee und Picasso', in *Zeitschrift für Kunst*, 4, no. 1, Leipzig 1950; J. CHARPIER, 'La Merveille concrète: note sur Paul Klee', in *Empédocle*, Paris 1950; L. DEGARD, 'Klee' in *Art d'Aujourd'hui*, nos. 7–8, Paris 1950; G. DORFLES, *Klee*, Milan 1950; M. DUCHAMP, *Collection of the Société Anonyme: Museum of Modern Art 1920*, New Haven 1950; H. F. GEIST, 'Paul Klee und die Welt des Kindes', in *Werk*, 37, no. 6, Winterthur 1950; W HAFTMANN, *Paul Klee: Wege bildnerischen Denkens*, Munich 1950; M. H. HEINTZ, 'Paul Klee zum 70. Geburtstag', in *Der Kunsthandel*, no. 1, Heidelberg 1950; W. HESS, *Die Farbe in der modernen Malerei*, Munich 1950; H. HILDEBRANDT, 'Paul Klees magische Welt', in *Wirtschaftszeitung*, no. 37, Stuttgart 1950; *History of Modern Painting from Picasso to Surrealism*, ed. Skira, Geneva 1950; D. H. KAHNWEILER, *Klee*, Paris and New York 1950; G. MARCHIORI, *Pittura moderna in Europa*, Venice 1950; E. NEWTON, 'Paul Klee on Art', in *In My View*, London 1950; A. PODESTÀ, 'Situazione critica di Klee', in *Emporium*, 101, no. 6622, Bergamo 1950; R. M. RILKE, *Lettres françaises à Merline*,

Paris 1950; S. RUDIKOFF, 'Notes on Paul Klee', in *Hudson Review*, 3, no. 1, New York 1950; H. SCHECK, 'Ein Maler des echten Spielens', in *Die Kommenden*, no. 12, Freiburg 1950; T. SCIALOJA, 'Apparizione di Klee', in *Letteratura; Arte Contemporanea*, I, no. 5, Florence 1950; J. A. THWAITES, 'Blaue Reiter, a Milestone in Europe', in *Art Quarterly*, 13, no. 1, Detroit 1950; R. TODD, 'The Man in the Paul Klee Mask', in *Art News*, 48, New York 1950; D. WILD, *Moderne Malerei: ihre Entwicklung seit dem Impressionismus*, Zurich 1950; R. G. BRUHL, 'Nuevos Aportes sobre el arte de Paul Klee', in *Ver y Estimar*, no. 25, Buenos Aires 1951; I. FALDI, 'Paul Klee', in *Habitat*, no. 3, São Paulo 1951; G. NICO FASOLA, *Ragione dell'arte astratta*, Milan 1951; G. A. FLANAGAN, *How to Understand Modern Art*, New York–London 1951; W. GROHMANN, *Paul Klee: Handzeichnungen*, Wiesbaden 1951; A. HENTZEN, review of W. Haftmann, 'Paul Klee: Wege bildnerischen Denkens', in *Kunstchronik*, no. 4, Nuremberg 1951; M. MURANO, 'Paul Klee, color y fabula', in *Ver y Estimar*, no. 25, Buenos Aires 1951; D. M. ROBB, *The Hasper History of Painting: The Occidental Tradition*, New York 1951; A. SCHMELLER, 'Romantischer Paul Klee', in *Wort und Wahrheit*, 6, Vienna 1951; G. SCHÖN, 'Ein Magier Kreuzt den Weg. Zu Bildern von Paul Klee', in *Rheinischer Merkur*, no. 8, Koblenz 1951; B. STABILE, 'Paul Klee y Juan Gris', in *Ver y Estimar*, no. 25, Buenos Aires 1951; C. GIEDION-WELCKER, *Paul Klee*, New York 1952; F. KLEE, 'Der Musiker Paul Klee', in *Schweizer Radio Zeitung*, 29, no. 9, Berne 1952; A. MORELLO, 'Paul Klee', in *Commentari*, 3, Rome 1952; P. F. SCHMIDT, *Geschichte der modernen Malerei*, Zurich 1952; S. VERESS, *Hommage à Paul Klee*, Berne 1952; W. GROHMANN, *Paul Klee, acquarelles et dessins*, Paris 1953; P. COURTHION, *Klee*, Paris 1953; K. GREBE, 'Paul Klee als Musiker', in *Tages-Anzeiger*, no. 14, Zurich 1953; M. RAYNAL, *Modern Painting*, Geneva 1953; G. SCHMIDT, *Paul Klee: Engel bringt das Gewünschte*, Baden-Baden 1953; A. FORGE, *Paul Klee*, London 1954; W. GROHMANN, *Paul Klee*, Geneva and Stuttgart 1954; M. BRION, *Klee*, Paris 1955; G. DI SAN LAZZARO, *Klee, la vie et l'oeuvre*, Paris 1957; W. GROHMANN, 'Klee' in *Enciclopedia Universale dell'Arte*, vol VIII, Venice–Rome 1958; W. GROHMANN, *Paul Klee*, Cologne 1959; *Erinnerungen an Paul Klee* (ed. L. Grote), Munich 1959; N. PONENTE, *Klee*, Geneva 1960; *Paul Klee par lui-même et par son fils Felix Klee*, translated and edited by M. Besset, Paris 1963; C. ROY, *Paul Klee, aux sources de la peinture*, Paris 1963; E. W. KORNFELD, *Verzeichnis des graphischen Werkes von Paul Klee*, Berne 1963; D. H. KAHNWEILER, 'A propos d'une conference de Klee', text from 1946, published in *Confessions esthétiques*, Paris 1963; W. GROHMANN, *Paul Klee*, Paris 1968.